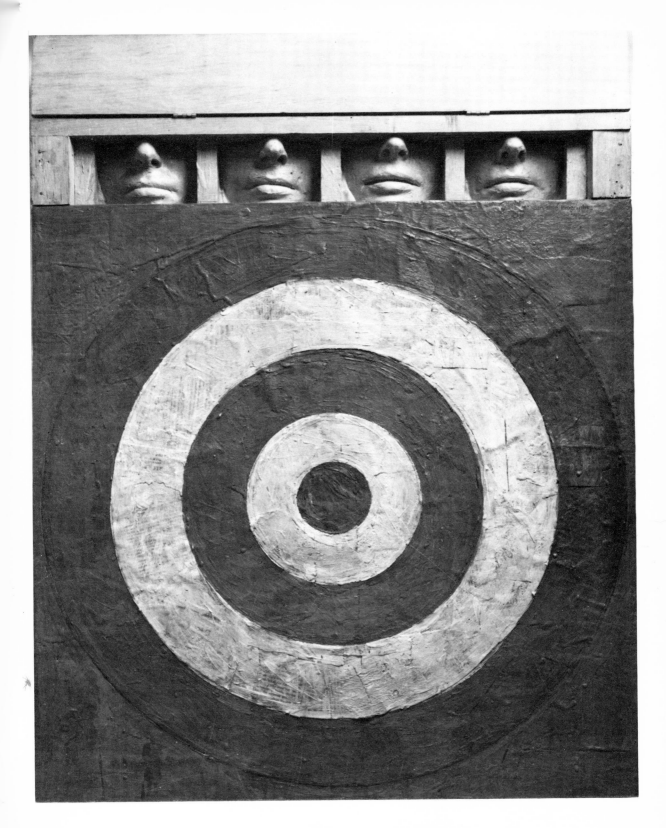

1. Jasper Johns. *Target with Four Faces*. 1955. Encaustic on newspaper on canvas, plaster and wood. 26 x 26. Museum of Modern Art, New York; Gift of Mr. and Mrs. Robert C. Scull, 1958.

AMERICAN POP ART

Lawrence Alloway

Macmillan Publishing Co., Inc.

NEW YORK

Collier Macmillan Publishers

LONDON

In association with the Whitney Museum of American Art

Library of Congress Cataloging in Publication Data

Alloway, Lawrence, 1926–
 American pop art.

 1. Pop art—United States. 2. Art, Modern—20th
century— United States. I. Title.
N6512.5.P6A55 1974 709'.73 73-22532
ISBN 0-02-627700-X
ISBN 0-02-000950-X (pbk.)

Macmillan Publishing Co., Inc.
866 Third Avenue, New York, N.Y. 10022
Collier-Macmillan Canada Ltd.

First Printing 1974

Printed in the United States of America

Acknowledgments

I am indebted to the Whitney Museum of American Art for inviting me to arrange the exhibition which is the occasion for the preparation of this book. James Monte prompted the project, and John I. H. Baur was unfailingly helpful in carrying it out. I am very grateful to the artists, private collectors, and public institutions who loaned the works that made possible the realization of my ideal plan for a Pop art exhibition. Pamela Adler worked with me on every aspect of the exhibition and book, demonstrating extraordinary resourcefulness and goodwill, and Jacki Ochs typed the manuscript under harassing circumstances. Leo Castelli in New York and Irving Blum in Los Angeles supported my research and contacts with artists beyond any reasonable expectations. My thanks are due to Roger Lax for designing a book exceptionally responsive to the author's intentions. Earlier versions of parts of the Lichtenstein and Rosenquist chapters appeared in *Artforum* and some of the Johns and Rauschenberg chapter in *Figurative Art Since 1945*. A part of "Definition" was one of the Granada Guildhall lectures in London in 1969. The exhibition was supported by a grant from the National Endowment for the Arts.

L. A.

To Sylvia

Catalog of the Exhibition

(Dimensions are in inches, height preceding width and depth.)

Richard Artschwager b. 1924

1. *Portrait I.* 1962. Mixed media. 74 x 26 x 12. Collection of Galerie Neuendorf, Hamburg, West Germany.
2. *Portrait II.* 1964. Formica on wood frame. 68⅝ x 26⅜ x 12¾. Collection of the artist.
3. *Table and Chair.* 1963–64. Formica on wood frame. 54 x 55 x 25. Collection of the artist.

Billy Al Bengston b. 1934

4. *Carburetor I.* 1961. Oil on canvas. 36 x 34. Collection of Artist Studio, Venice, California.
5. *Gas Tank & Tachometer.* 1961. Oil on canvas. 42 x 40. Collectoin of Edward Ruscha, Los Angeles, California.
6. *Ideal Exhaust.* 1961. Oil on canvas. 42 x 40. Collection of Artist Studio, Venice, California.
7. *Skinny's 21.* 1961. Oil on canvas. 42 x 40. Collection of Dr. and Mrs. Mac L. Sherwood, Beverly Hills, California.

Allan D'Arcangelo b. 1930

8. *Marilyn.* 1962. Acrylic on canvas. 60 x 54. Collection of the artist.
9. *Madonna and Child.* Acrylic on canvas. 68½ x 60. 1963. Collection of the artist.

Jim Dine b. 1935

10. *Child's Blue Wall.* 1962. Oil, wood, metal, light bulb. 60 x 72. Collection of Albright-Knox Art Gallery, Buffalo, New York; Gift of Seymour H. Knox.
11. *Four Rooms.* 1962. Oil, metal, rubber, upholstered chair. 72 x 180. Collection of Sonnabend Gallery, New York.
12. *Hatchet with Two Palettes, State No. 2.* 1963. Oil on canvas with wood and metal. 72 x 54 x 12. Collection of Harry N. Abrams family, New York.
13. *Two Palettes (International Congress of Constructivists and Dadaists, 1922).* 1963. Oil on canvas with collage. 72 x 72. Collection of A. I. Sherr, New York.
14. *Red Robe with Hatchet (Self Portrait).* 1964. Oil on canvas with metal and wood. 60 x 60 x 23. Collection of Mr. and Mrs. Sydney Lewis, Richmond, Virginia.
15. *Nancy and I in Ithaca (Straw Heart).* 1966–69. Sheet iron and straw. 60 x 70 x 12½. Collection of Sonnabend Gallery, New York.

Joe Goode b. 1937

16. *Bo. 1962.* Oil on canvas with glass. 72 x 72. Collection of Mr. and Mrs. James Corcoran, Los Angeles, California.
17. *Happy Birthday.* 1962. Oil on canvas. 65½ x 65½. Collection of Janss Foundation, Thousand Oaks, California.
18. *Staircase.* 1970. Mixed media. 96 x 97 x 8⅞. Collection of Ron Cooper, Venice, California.
19. *Staircase.* 1970. Mixed media. 48 x 71 x 48. Collection of the artist.

Phillip Hefferton b. 1933

20. *Sinking George.* 1962. Oil on canvas. 90 x 67½. Collection of Betty and Monte Factor Family, Los Angeles, California.

Robert Indiana b. 1928

21. *The Calumet.* 1961. Oil on canvas. 90 x 94. Collection of Rose Art Museum, Brandeis University, Waltham, Massachusetts.
22. *Year of Meteors.* 1961. Oil on canvas. 90 x 84. Collection of Albright-Knox Art Gallery, Buffalo, New York.
23. *Eat/Die. 1962.* Oil on canvas. Two paintings, each 72 x 60. Collection of the artist.
24. *The X-5.* 1963. Oil on canvas. 108 x 108. Collection of Whitney Museum of American Art, New York.
25. *Louisiana.* 1966. Oil on canvas. 70 x 60. Collection of Krannert Art Gallery, University of Illinois, Champaign, Illinois.

Jasper Johns b. 1930

26. *Tango.* 1955. Encaustic on canvas with music box. 43 x 55. Collection of Mr. and Mrs. Burton Tremaine, Meriden, Connecticut.
27. *Target with Four Faces.* 1955. Encaustic on newspaper on canvas, plaster, and wood. 26 x 26. Collection of Museum of Modern Art, New York; Gift of Mr. and Mrs. Robert C. Scull, 1958.
28. *Target with Plaster Casts.* 1955. Encaustic and collage on canvas with plaster casts. 51 x 44 x 3½. Collection of Mr. and Mrs. Leo Castelli, New York.
29. *Grey Flag.* 1957. Encaustic and collage on canvas. 38 x 26. Collection of James Holderbaum, Smith College, Northampton, Massachusetts.
30. *Alley Oop.* 1958. Oil and collage on board. 23 x 18. Collection of Robert Rauschenberg, New York
31. *Three Flags.* 1958. Encaustic on canvas. 30⅞ x 45½ x 5. Collection of Mr. and Mrs. Burton Tremaine, Meriden, Connecticut.
32. *White Numbers.* 1959. Encaustic on canvas. 53¼ x 40. Collection of Mr. and Mrs. Victor W. Ganz, New York.
33. *Studio No. 2.* 1966. Oil on canvas. 70 x 125. Collection of Mr. and Mrs. Victor W. Ganz, New York.
34. *Harlem Light.* 1967. Oil on canvas with collage. 78 x 172. Collection of David Whitney, New York.

Roy Lichtenstein b. 1923

35. *Blam.* 1962. Oil on canvas. 68 x 80. Collection of Richard Brown Baker, New York.

36. *Golf Ball*. 1962. Oil on canvas. 32 x 34. Collection of Mr. and Mrs. Melvin Hirsh, Beverley Hills, California.
37. *As I Opened Fire*. . . . 1963. Oil on canvas. 68 x 168. Collection of Stedelijk Museum, Amsterdam, The Netherlands.
38. *Woman with a Flowered Hat*. 1963. Magna on canvas. 50 x 40. Private collection.
39. *We Rose Up Slowly*. . . . 1964. Oil and magna on canvas. 68 x 92. Collection of Karl Ströher, Hessischen Landesmuseum, Darmstadt, West Germany.
40. *Mirror (In Six Panels)*. 1971. Oil and magna on canvas. 120 x 132. Collection of the artist.
41. *Still Life with Crystal Bowl, Lemon, Grapes*. 1973. Oil and magna on canvas. 40½ x 54¾. Collection of the artist.

Claes Oldenburg b. 1929

42. *U.S.A. Flag*. 1960. Muslin soaked in plaster over wire frame, painted with tempera. 24 x 30 x 3½. Collection of the artist.
43. *Auto Tire and Price (Auto Tire with Fragment of Price)*. 1961. Muslin soaked in plaster over wire, painted with enamel. 49 x 48 x 7. Collection of Pat Oldenburg, New York.
44. *Store Ray Gun*. 1961. Muslin soaked in plaster over wire frame, painted with enamel. 29¾ x 35⅛ x 9. Collection of Letty Lou Eisenhauer, New York.
45. *Bedroom Ensemble*. 1963. Wood, vinyl, metal, fake fur, and other materials. 204 x 252. Collection of the artist.
46. *Soft Pay-Telephone*. 1963. Vinyl filled with kapok, mounted on painted wood panel. 46½ x 19 x 12. Collection of William Zierler, New York.
47. *Shoestring Potatoes Spilling from a Bag (Falling Shoestring Potatoes)*. 1965–66. Canvas filled with kapok, painted with glue and Liquitex. 108 x 46 x 42. Collection of Walker Art Center, Minneapolis, Minnesota.
48. *Soft Manhattan II, Subway Map*. 1966. Canvas filled with kapok, impressed with patterns in sprayed enamel, wooden sticks, wood rod. 68 x 32 x 7. Collection of Pat Oldenburg, New York.
49. *Ghost Drum Set*. Wood on canvas painted with Liquitex. 72 x 72 x 28. 1972. Collection of the artist.

Mel Ramos b. 1935

50. *Batman*. 1962. Oil on canvas. 30½ x 26. Collection of Scot Ramos, Oakland, California.
51. *Batmobile*. 1962. Oil on canvas. 50 x 44. Collection of Peter Ludwig, Neue Galerie, Aachen, West Germany.
52. *The Joker*. 1962. Oil on canvas. 11 x 10. Private collection, New York.
53. *Phantom #2*. 1963. Oil on canvas. 36 x 18. Collection of Charles Cowles, New York.

Robert Rauschenberg b. 1925

54. *Bed*. 1955. Combine-painting. 74 x 31. Collection of Mr. and Mrs. Leo Castelli, New York.

55. *Rebus.* 1955. Combine-painting. 96 x 44. Collection of Mr. and Mrs. Victor W. Ganz, New York.

56. *Monogram.* 1959. Construction. 48 x 72 x 72. Collection of Moderna Museet, Stockholm, Sweden.

57. *Persimmon.* 1964. Oil on canvas with silk screen. 66 x 50. Collection of Mr. and Mrs. Leo Castelli, New York.

58. *Tracer.* 1964. Oil on canvas with silk screen. 84 x 60. Collection of Frank M. Titelman, Boca Raton, Florida.

59. *Trapeze.* 1964. Oil on canvas with silk screen. 120 x 48. Collection of Galerie de Sperone, Turin, Italy.

Larry Rivers b. 1923
60. *Buick Painting with P.* 1960. Oil on canvas. 42 x 54. Anonymous lender.

James Rosenquist b. 1933
61. *1947, 1948, 1950.* 1960. Oil on masonite. 30 x 87⅜. Collection of the artist.

62. *Woman #2.* 1962. Oil on canvas. 70 x 70. Collection of Mr. and Mrs. Morton G. Neumann, Chicago, Illinois.

63. *Silo.* 1963–64. Oil on canvas. 114 x 140 x 24. Collection of Tate Gallery.

64. *Director.* 1964. Oil on canvas. 90 x 62. Collection of Mr. and Mrs. Robert B. Mayer, Winnetka, Illinois.

65. *Time Flowers.* 1973. Oil silk-screened on canvas. 68 x 83½. Collection of Max Palevsky, Los Angeles, California.

Edward Ruscha b. 1937
66. *20th Century Fox with Searchlights.* 1961. Oil on canvas. 67½ x 133¾. Collection of Stephen Mazoh & Co., Inc., New York.

67. *Annie.* 1962. Oil on canvas. 71 x 66½. Private collection, Los Angeles, California.

68. *Annie, Poured from Maple Syrup.* 1966. Oil on canvas. 55 x 59. Collection of Pasadena Museum of Modern Art, Pasadena, California; Gift of the Women's Committee.

69. *Noise, Pencil, Broken Pencil, Cheap Western.* 1966. Oil on canvas. 71 x 66½. Collection of Locksley-Shea Gallery, Minneapolis, Minnesota.

Andy Warhol b. 1925
70. *Popeye.* 1961. Acrylic on canvas. 68 x 59. Collection of Robert Rauschenberg, New York.

71. *Before and After, 3.* 1962. Synthetic polymer on canvas. 74 x 100. Collection of Whitney Museum of American Art, New York; Gift of Charles Simon (and purchase).

72. *Marilyn Monroe Diptych.* 1962. Acrylic on canvas. 82 x 114. Collection of Mr. and Mrs. Burton Tremaine, Meriden, Connecticut.

73. *1947 – White.* 1963. Silk screen on canvas. 121 x 78. Collection of Luciano Pomini, Castellanza, Italy.

74. *Lavender Disaster.* 1964. Silk screen on canvas. 108 x 82. Collection of Mr. and Mrs. Peter M. Brant, Greenwich, Connecticut.

Tom Wesselmann b. 1931

75. *Bathtube Nude Number 2*. 1963. Mixed media. 48 x 72. Collection of Locksley-Shea Gallery, Minneapolis, Minnesota.

76. *Bathtub Nude Number 3*. 1963. Mixed media. 84 x 106 x 17¾. Collection of Peter Ludwig, Wallraf-Richartz Museum, Cologne, West Germany.

77. *Great American Nude Number 54*. 1964. Mixed media. 84¼ x 102⅓ x 52⅓. Collection of Peter Ludwig, Neue Galerie, Aachen, West Germany.

An exhibition organized for and shown at the
Whitney Museum of American Art, April 6 – June 16, 1974,
with support from the National Endowment for the Arts

CONTENTS

Acknowledgments v
Catalog of the Exhibition viii

Introduction 1
1. Definition 3
2. Signs and Objects 24
3. Artists 52
 Jasper Johns and Robert Rauschenberg 52
 Roy Lichtenstein 75
 James Rosenquist 86
 Claes Oldenburg 98
 Andy Warhol 104
4. Context 115
Notes 127
Bibliography 133
Index 141

INTRODUCTION

In 1964, Bob Watts embarked on a project to copyright the words *Pop Art*, thereby taking the term off the market and preventing its use, perhaps in anticipation of its extensive use as a marketing label on a variety of products. [1] I used to wish that I had copyrighted the term myself, not to restrict its use but to collect royalties. Watts discovered, after a search of patents, many trade names that were already registered, including "POP" (plumbing hardware), POP (metal casings), POPS (pliers), POP'S (men's underwear), and POP-POPS (candy). However since Pop art had already become part of art criticism, it was judged to be a generic term and thus not subject to copyright.

The term *Pop art* originated in England and reached print by the winter of 1957–58. [2] Pop art and Popular art were both used at this time to refer approvingly to the products of the mass media. It was part of a tendency to consider mass-produced sign-systems as art, part of an expansionist aesthetic with a place for both abstract expressionism and Hollywood, the Bauhaus and Detroit styling.

In the early 60s the term became attached to the fine arts exclusively, usually for paintings with a source in popular culture. This second usage of Pop art was, therefore, counter-expansionist, concentrating the once-broad term on a particular kind of art. This is the definition of the term assumed here. Throughout the 60s, use of the term spread. Here is an example of Pop art absorbed by Pop culture, a story in the *Wall Street Journal* headlined, "When a Working Wife Leaves Her Job." "To save money, she has confined her artistic efforts to clipping old magazine pictures, arranging them on cardboard and shellacking them. When asked, she will hesitantly show visitors her latest work, an attractive brown-and-gold mélange she says is 'strictly pop art'." [3] However the professional artists who made references to popular culture in their work

1

retained the prevailing ideas of New York painting concerning aesthetic unity. The expansionist aspect of the earlier use of the term became identified with Allan Kaprow's term *Happening*. Happenings carried the *Gesamtkunstwerk* from Wagner to downtown New York. As Kaprow wrote, "A walk down 14th Street is more amazing than any masterpiece of art," being "endless, unpredictable, infinitely rich."[4] The Happening stays close to "the totality of nature," whereas Pop artists work from the artifacts of culture and retain the compact identity of art no matter how extensively they quote from the environment.

2

1. DEFINITION

Ours is the age of advertisement and publicity
—Søren Kierkegaard

The aesthetics of twentieth-century art, or much of it, derive from the eighteenth-century separation of the arts from one another.[1] Art was strictly defined as pure painting, sculpture, architecture, music, or poetry, and nothing but these five media could be properly classified as fine art. This act of tight discrimination was powerfully reinforced in the succeeding centuries. Nineteenth-century aestheticism sought the pure center of each art in isolation from the others, and twentieth-century formal theories of art assumed a universal equilibrium that could be reached by optimum arrangements of form and color. No sooner were the arts purified by eighteenth-century definitions than the supporters of pure fine art declared their differences from the popular audience which was not committed to high art. Henry Fielding, Oliver Goldsmith, and Dr. Johnson all recorded their alarm at the gross new public's taste for realism and sensationalism in novels and plays. Anxieties were expressed about the effects of novels on young ladies—anxieties which were very like the fears of parents and teachers in the 50s about the effect of horror comics on children and in the 60s about the effect of the violence shown on TV. Connections exist between fine and popular art, but they are not numerous: Hogarth worked for a socially differentiated public, with paintings intended for an affluent and sophisticated audience and prints aimed at a mass audience. Goya drew on English political prints for his execution picture, *The Third of May, 1808*.[2] Daumier alternated between the directed messages of his political cartoons and the autonomous paintings. Toulouse-Lautrec's posters were pasted on kiosks in the streets of Paris. Despite such individual reconciliations of fine and popular art, of elite artist and public taste, representatives of the two taste groups have remained antagonists.

3

As the popular arts became increasingly mechanized and progressively more abundant, elite resistance hardened correspondingly. Popular culture can be defined as the sum of the arts designed for simultaneous consumption by a numerically large audience. Thus, there is a similarity in distribution and consumption between prints, on the one hand, and magazines, movies, records, radio, TV, and industrial and interior design, on the other. Popular culture originates in urban centers and is distributed on the basis of mass production. It is not like folk art which, in theory at least, is handcrafted by the same group by which it will be consumed. The consumption of popular culture is basically a social experience, providing information derived from and contributing to our statistically normal roles in society. It is a network of messages and objects that we share with others.

Popular culture is influential as it transmits prompt and extensive news, in visual, verbal, and mixed forms, about style changes that will affect the appearance of our environment or about political and military events that will put our accepted morality under new pressures. There is a subtle and pervasive, but only half-described, feedback from the public to the mass media and back to the public in its role as audience. The media have expanded steadily since the eigteenth century, without a break or major diversion. The period after World War II was Edenic for the consumer of popular culture: technical improvements in color photography in magazines, expansion of scale in the big screens of the cinema, and the successful addition of new media (long-playing records and television). In addition, cross-references between media increased, so that public communication expanded beyond its status of "relax-ation" (the old rationalization for reading detective stories) or invisible service (such as providing essential political and national news).

Marshall McLuhan believes that the arrival of a new medium consigns prior media to obsolescence. It is true that each new channel of communication has its effect on the existing ones, but so far the effect has been cumulative and expansive. The number of possibilities and combinations increases with each new channel, whereas McLuhan assumes a kind of steady state of a number of messages which cannot be exceeded. Consider the relation of movies and TV. At first, movies patronized the tiny screen and the low-definition image in asides in films; then movies began to compete with TV by expanding into large screens (CinemaScope and Cinerama, for instance) and by using higher-definition film stock (for example, VistaVision). (Three-dimensional movies were resurrected but did not get out of the experimental stage.) Today, TV shows old movies (more than two years old) continually and in so doing has created a new kind of Film Society audience of TV-trained movie-goers. In addition to making TV films, Hollywood is making sexier and tougher films, leaving the delta of family entertainment largely to TV. Movies, now, are more diversified and aimed at more specialized audiences, which is not what McLuhan's theory (which would expect the extinction of the movie) requires.

After World War II, the critical study of Pop culture developed in ways that surpassed in sophistication and complexity earlier discussions of the mass media. To Marxists, Pop culture was what the bosses drugged the people with

and to Freudians it was primal fantasy's topical form, with a *vagina dentata* in every crocodile in the cave under the mad doctor's laboratory. The new research was done by American sociologists who treated mass communications objectively, as data with a measurable effect on our own lives. In fact, the study of mass communications and public opinion is a characteristic of American sociology compared to European. The public's reception of ideas and images and their distribution among the public have been charted and analyzed in a manner commensurate with the development of the mass media in the United States. There may be an analogy here with the postwar move among historians away from heroes and dominant figures to the study of crowds. Previously, the past had been discussed in terms of generals' decisions, monarchs' reigns, and mistresses' fortunes, with the rest of the world serving as an anonymous background. The practice of treating history as a star system was not really subverted by debunking portraits of the great, à la Lytton Strachey, which preserved, though ironically, the old ratio of hero and crowd. The real change came with the study of population and communities. Demography is giving to normal populations something of the legibility of contour that biography confers on individuals. The democratization of history (like the sociological study of mass communications) leads to an increase of complexity in the material to be studied, making it bulge inconveniently beyond the traditional limits of inquiry.

In the postwar period an uncoordinated but consistent view of art developed, more in line with history and sociology than with traditional art criticism and aesthetics. In London and New York, artists then in their twenties or early thirties revealed a new sensitivity to the presence of images from mass communications and to objects from mass production assimilable within the work of art. Robert Rauschenberg, writing about Oyvind Fahlstrom, described the artist as "part of the density of an uncensored continuum that neither begins nor ends with any action of his."[3] Instead of the notion of painting as technically pure and organized as a nest of internal correspondences, Rauschenberg proposed that the work of art was a partial sample of the world's continuous relationships. It follows that works demonstrating such principles would involve a change in our concept of artistic unity: art as a rendezvous of objects and images from disparate sources, rather than as an inevitably aligned setup. The work of art can be considered as a conglomerate, no one part of which need be causally related to other parts; the cluster is enough. Rauschenberg's combine-paintings and silk-screen paintings investigate the flow of random forms and the emergence of connectivity within scatter.

As popular culture became conspicuous after World War II, as history and sociology studied the neglected mass of the past and the neglected messages of the present, art was being changed, too. It is not, as ultimatistic writers have it, that the emergence of a new style obliterates its predecessors. What happens is that everything changes, but the past's continuity with the present is not violated. As an alternative to an aesthetic that isolated visual art from life and from the other arts, there emerged a new willingness to treat our whole culture as if it were art. This attitude opposed the elite, idealist, and purist

5

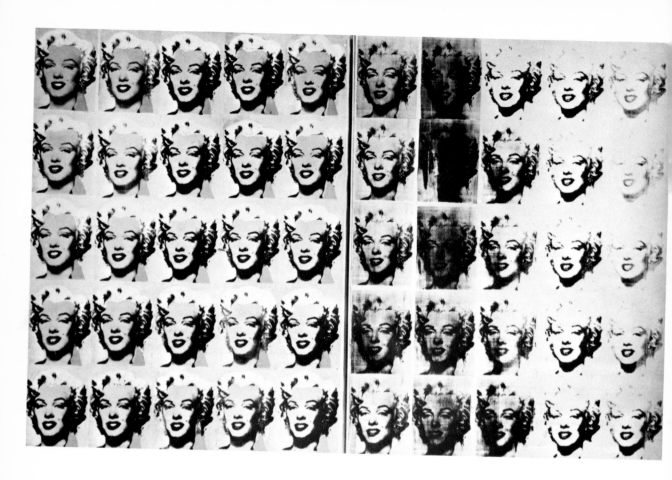

2. Andy Warhol. *Marilyn Monroe Diptych*. 1962. Acrylic on canvas. 82 x 114. Collection of Mr. and Mrs. Burton Tremaine, Meriden, Connecticut.

elements in eighteenth- to twentieth-century art theory. What seems to be implicit here is an anthropological description of our own society. Anthropologists define culture as all of a society. This is a drastic foreshortening of a very complex issue in anthropology, but to those of us brought up on narrow and reductive theories of art, anthropology offers a formulation about art as being more than a treasury of precious items. It was a two-way process: the mass media entered the work of art, and the whole environment was regarded, reciprocally, by the artists as art, too. Younger artists did not view Pop culture as relaxation, but as an ongoing part of their lives. They felt no pressure to give up the culture they had grown up in (comics, pop music, movies). Their art was not the consequence of renunciation but of incorporation.

Pop art is neither abstract nor realistic, though it has contacts in both directions. The core of Pop art is at neither frontier; it is, essentially, an art about signs and sign-systems. Realism is, to offer a minimal definition, concerned with the artist's perception of objects in space and their translation into iconic, or faithful, signs. However, Pop art deals with material that already exists as signs: photographs, brand goods, comics—that is to say, with precoded material. The subject matter of Pop art, at one level, is known to the spectator in advance of seeing the use the artist makes of it. Andy Warhol's Campbell's Soup cans, Roy Lichtenstein's comic strips are known either by name or by type, and their source remains legible in the work of art.

What happens when an artist uses a known source in popular culture in his art is rather complex. The subject of the work of art is doubled: if Roy Lichtenstein uses Mickey Mouse in his work, Mickey is not the sole subject. The original sign-system of which Mickey is a part is also present as subject. The communication system of the twentieth century is, in a special sense, Pop art's subject. Marilyn Monroe, as used by Andy Warhol, is obviously referred to, but in addition, another channel of communication besides painting is referred to as well. Warhol uses a photographic image that repeats like a sheet of contact prints and is colored like the cheap color reproduction in a Spanish-language film magazine.

There has been some doubt and discussion about the extent to which the Pop artist transforms his material. The first point to make is that selecting one thing rather than another is, as Marcel Duchamp established, sufficient. Beyond this, however, is the problem raised by Lichtenstein who used to say, apropos of his paintings derived from comics, that he wanted to compose, not to narrate, but this is precisely what transformed his source. I showed early comic strip paintings by Lichtenstein to a group of professional comic strip artists who considered them very arty. They thought his work old-fashioned in its flatness. Lichtenstein was transforming after all, though to art critics who did not know what comics looked like, his work at first appeared to be only a copy. In fact, there was a surreptitious original in the simulated copy. Pop art is an iconographical art, the sources of which persist through their transformation; there is an interplay of likeness and unlikeness. One way to describe the situation might be to borrow a word from the military-industrial complex, *commonality*, which refers to equipment that can be used for different pur-

3. Allan D'Arcangelo. *Marilyn.*
1962. Acrylic on canvas. 60 x 54.
Collection of the artist.

4. Allan D'Arcangelo. *Madonna
and Child.* 1963. Acrylic on can-
vas. 68½ x 60. Collection of the
artist.

poses. One piece of hardware is common to different operations; similarly, a sign or a set of signs can be common to both popular culture and Pop art. The meaning of a sign is changed by being recontextualized by the artist.

The success of Pop art was not due to any initial cordiality by art critics. On the contrary, art critics in the late 50s and early 60s were, in general, hostile. One reason for this is worth recording, because it is shared by Clement Greenberg and Harold Rosenberg, to name the supporters of irreconcilable earlier modernisms. Greenberg, with his attachment to the pure color surface, and Rosenberg, with his commitment to the process of art, are interested only in art's unique identity. They locate this at different points—Greenberg in the end product and Rosenberg in the process of work, but Pop art is not predicated on this quest for uniqueness. On the contrary, Pop art constantly reveals a belief in the translatability of the work of art. Pop art proposes a field of exchangeable and repeatable imagery. It is true that every act of communication, including art, has an irreducible uniqueness; it is equally true that a great deal of any message or structure is translatable and homeomorphic. Cross-media exchanges and the convergence of multiple channels is the area of Pop art, in opposition to the pursuit of an artistic purity.

Thus Pop art is able to share, on the bases of translatability and commonality, themes from popular culture. Any event today has the potential of spreading through society on a multiplicity of levels, carried by a fat anthology of signs. It is impossible to go into the full extent of the connections between popular culture and Pop art, but the extent of the situation can be indicated by a few representative crossovers. Lichtenstein made a cover for *Newsweek* when the magazine ran a Pop art survey in 1966, and Robert Rauschenberg silk-screened a cover for *Time* on the occasion of a story on *Bonnie and Clyde*. Here, artists who draw on the field of mass communications are themselves contributing to it. Some of the best photographs of Edward Kienholz's environmental sculptures appeared in a girlie magazine, *Night and Day*. As art is reproduced in this way, it becomes itself Pop culture, just as the works of van Gogh and Picasso, through endless reproduction, have become mass-produced items of popular culture. Van Gogh would have welcomed it because he had the greatest respect for clichés, which he regarded as the authorized expression of mankind, a kind of common property that especially binds us together.

In New York, the first large paintings derived from comic strips were by Andy Warhol in 1960, such as his *Popeye*. The following year, Lichtenstein made his first painting of this type, a scene of Mickey Mouse and Donald Duck. Though actually taken from a bubble-gum wrapper, the style of drawing and the kind of incident resemble comic strips based on Walt Disney's film cartoon characters. Previously, Lichtenstein had done cubist versions of nineteenth-century cowboy paintings and of World War I dogfights, "the *Hell's Angels* kind of thing," to quote the painter. The contrast of popular subjects (cowboys and Indians, old planes) and their Picasso-esque treatment is certainly proto-Pop. Lichtenstein did not know Warhol's slightly earlier work but was, independently, on a track that led logically to the comics. Early Pop art, in fact,

9

5. Robert Rauschenberg. *Mona Lisa.* 1958. Mixed media on paper. 22¾
x 28¾.

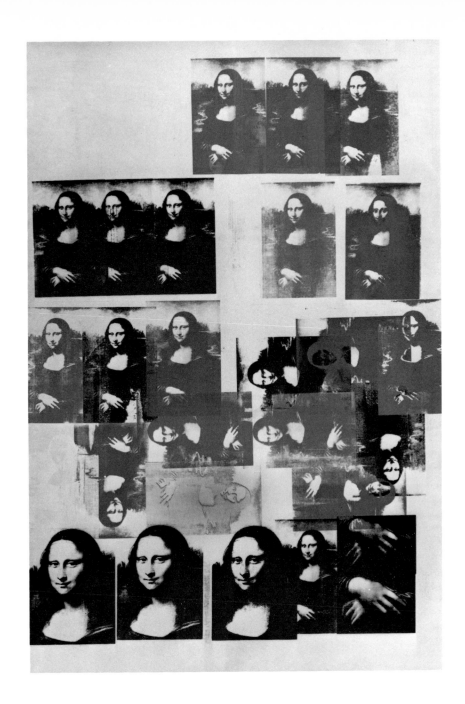

6. Andy Warhol. *Mona Lisa.* 1963. Silk screen on canvas. 128 x 82. Collection of Eleanor Ward, New York.

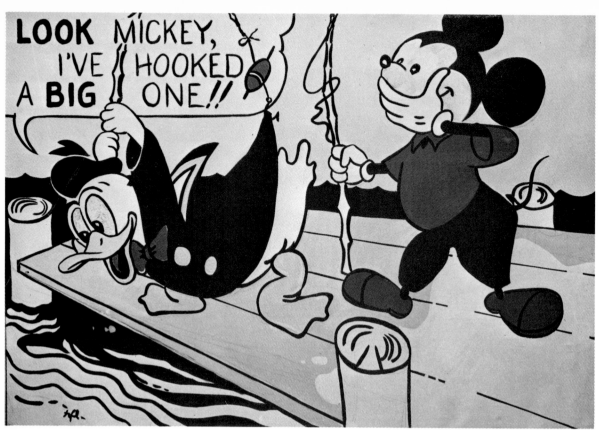

7. Roy Lichtenstein. *Look Mickey.* 1961. Oil on canvas. 48 x 60. Collection of the artist.

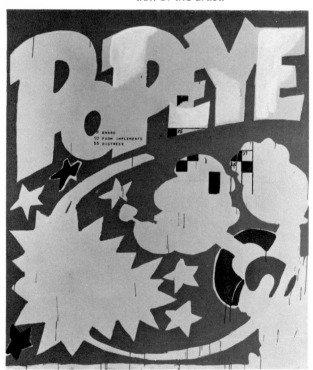

8. Andy Warhol. *Popeye.* 1961. Acrylic on canvas. 68 x 59. Collection of Robert Rauschenberg, New York.

9. Andy Warhol. *Dick Tracy.* 1962. Oil on canvas. 72 x 54. Collection of the Locksley-Shea Gallery, Minneapolis, Minnesota.

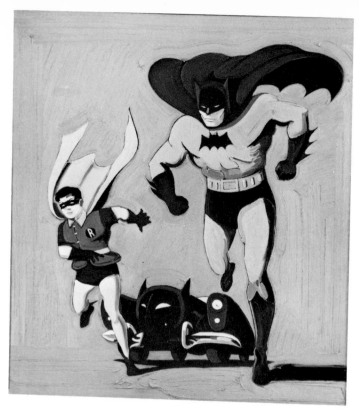

10. Mel Ramos. *Batmobile*. 1962.
Oil on canvas. 50 x 44. Collection
of Peter Ludwig, Neue Galerie,
Aachen, West Germany.

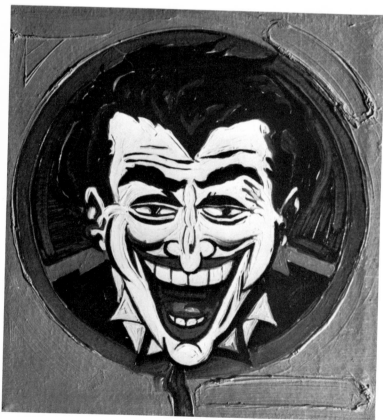

11. Mel Ramos. *The Joker*. 1962.
Oil on canvas. 11 x 10. Private
collection, New York.

12. Roy Lichtenstein. *Emeralds* 1961. Oil on canvas. 68½ x 68½. Collection of Reggie Cabral.

13. Anon. A "modernized" version of Roy Lichtenstein's *Emeralds* by a comic book artist. 1962. Pencil on paper. 5 x 8.

is peppered with convergences of separate artists on shared subjects. The fact of simultaneous discovery is, I think, a validation of the seriousness of the movement and refutes criticism of Pop art as a sudden or momentary affair. It would not have developed spontaneously in different places in the late 50s had it not been an authentic response to an historical situation.

The different uses that have been made of comics substantiate the continued independence of the artists after they had become aware of their common interest. Lichtenstein does not use famous figures of the comics, as Warhol took Popeye or Mel Ramos took Batman. Lichtenstein's paintings derive from specific originals, but the reference is always to realistic and anonymous originals. He uses war comics and love comics in preference to named heroes or fantastic comics. Ramos, on the contrary, began a series of Batman paintings in 1962, taken directly from Bob Kane's originals (and other artists who draw Batman) but rendered in succulent paint. Ramos then turned to painting sex heroines from precode comics, and here became engaged in historical research in erotic iconography (*Mysta of the Moon*; *Glory Forbes, Vigilante*; *Gale Allen, Girl Squadron Leader*; *Futura*, are some of the names). Then, in the June 1966 *Batman*: "At the Gotham City Museum, Bruce Wayne, Millionaire Sportsman and Playboy (Batman), and his young ward Dick Grayson (Robin), attend a sensational 'Pop art' show." On the walls are full-length, fine-art portraits that resemble the girlie paintings of Mel Ramos. Here is a feedback circuit that goes from comics to artist and back to comics. Linkages between art and Pop culture and between one part of Pop culture and another are not confined to the comics. In fashion, for example, Yves St. Laurent discovered Mondrian through an art book his mother gave him, and Courrèges' earlier designs had a science-fiction potential realized in the movie, *The 10th Victim*, and in *Harpers' Bazaar* photographs.

A unifying thread in recent art, present in Pop art, can be described as process abbreviation. In the past, an ambitious painting required a series of steps by the artist: from a conceptual stage, through preliminary sketches, to drawing, to underpainting, to glazing, and, maybe, to varnishing. These discrete steps were not experienced in isolation by the artist, of course, but such was basically the sequence of his operations. In one way and another, modern art has abbreviated this process. For instance, Pop artists have used physical objects as part of their work or rendered familiar articles with a high degree of literalness. Though Lichtenstein works in stages, he simulates an all-at-once, mechanical look in his hand-done painting. The finished work of art is thus separated from traces of its long involvement in planning and realizing, at least in appearance and sometimes in fact. Warhol's silk-screen paintings achieve a hand-done look from the haste and roughness with which the identical images are printed. Photographs, printed or stenciled, in the work of art give the most literal definition available in flat signs to the artist. Similarly, in the nineteenth century, the daguerreotype was described as a means "by which objects may be made to delineate themselves."[4]

Where process abbreviation is found in Pop art, it reduces personal nuances of handling by the artist in favor of deadpan or passive images. This deceptive

14. Robert Rauschenberg. *Crocus*. 1962. Oil on canvas. 60 x 36. Leo Castelli Gallery, New York.

impersonality amounts to a game with anonymity, a minimizing of invention, so that the work is free to support its interconnections with popular culture and with the shared world of the spectator. Photographs appear as unmediated records of objects and events, as the real world's most iconic sign-system. In addition to this property, which Rauschenberg and Warhol have exploited, photographs have a materiality of their own, a kind of visual texture which is generated mechanically, but which we read as the skin of reality, of self-delineated rather than of interpreted objects. This zone of gritty immediacy, of artificial accuracies, has been explored by Pop artists as part of their attention to multi-leveled signs.

Perhaps enough has been said to indicate that Pop art is not the same as popular culture, though it draws from it, and the point may have been made that Pop art is art. In the period since the term began to be used in London in 1957-58, its meaning shifted in a way that indicates resistance to an anthropological definition of culture. The term was, in the first place, part of an expansionist aesthetics, a way of relating art to the environment. In place of an hierarchic aesthetics keyed to define greatness and to separate high from low art, a continuum was assumed which could accommodate all forms of art, permanent and expendable, personal and collective, autographic and anonymous. From about 1961 to 1964, the term *Pop art* was narrowed to mean paintings that included a reference to a mass-medium source. As the term became attached purely to art, its diffusion accelerated.

The Random House Dictionary of the English Language (Unabridged Edition) defines Pop art as follows: "a style, esp. of figurative painting, developed in the U.S. and current in the early 1960's, characterized chiefly by magnified forms and images derived from such commercial art genres as comic strips and advertising posters."

In 1965-66 one aspect of the term shifted again, away from the second phase of its use, which is what the dictionary recorded. It was returned to the continuous and nonexclusive culture which it was originally supposed to cover. The term leaked back to the environment, much as Allan Kaprow's term *Happenings* spread to apply to everything and anything. Both words were taken up and used so promiscuously that Pop art was de-aestheticized and re-anthropologized. The dictionary I quoted stressed Pop art's American-ness. The United States, as the world's expected future form, the country at a level of industrialism to which all countries were headed, though at various speeds, was a model. There was a mood of optimism that is not in accord with present feelings, but the point remains that Pop art is an art of industrialism, and not only of America as such. It is the maximum development of its communications and the proliferation of messages that give America its centrality in Pop culture. Its dominance in Pop art is something else, and here we must refer to the professional art world of New York.

What is characteristic and entirely American about Pop art is the high level of technical performance. Johns' mastery of paint handling, Rauschenberg's improvisatory skill, Lichtenstein's locked compositions, Warhol's impact as an image maker, reach the point that they do because of the high level of infor-

Plate 1. Tom Wesselmann. *Bathtub Nude Number 3*. 1963. Mixed media. 84 x 106 x 17¾. Collection of Peter Ludwig, Wallraf-Richartz Museum, Cologne, West Germany.

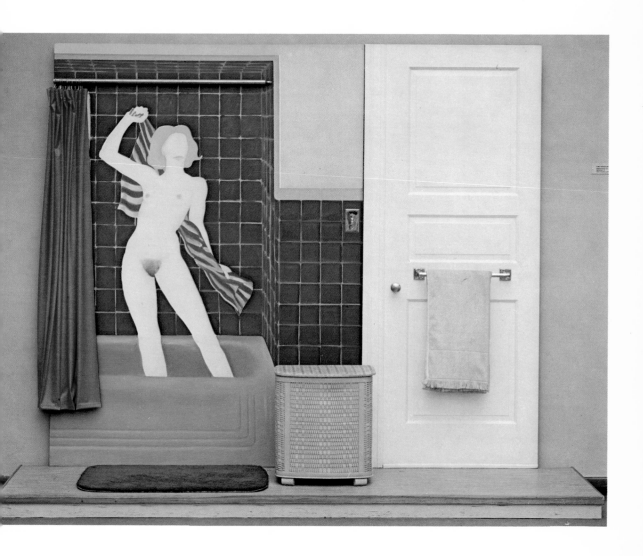

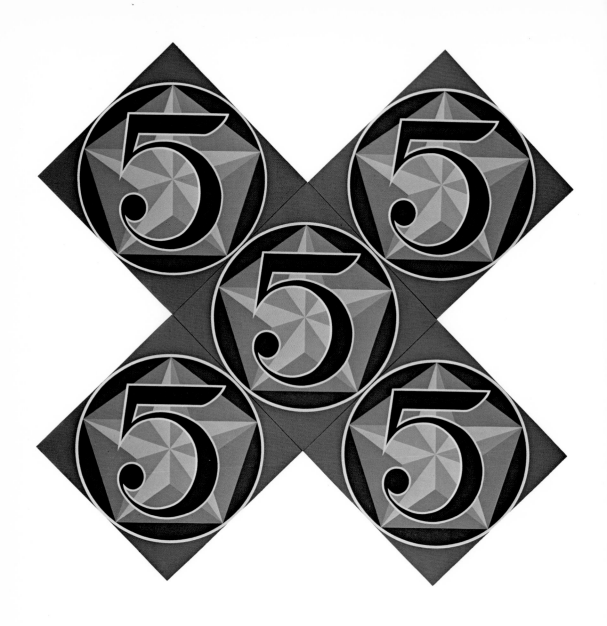

Plate 2. Robert Indiana. *The X-5*. 1963. Oil on canvas. 108 x 108. Collection of Whitney Museum of American Art, New York.

mation about art in New York. In the background are the abstract expression-
ists, setting an aesthetic standard of forceful presence and impeccable unity.
In addition, the Pop artists' peers were largely abstract painters, like Frank
Stella and Ellsworth Kelly, and Pop artists shared with them a sense of how
paintings should cohere holistically. This has sometimes been taken to mean
that the Pop artists were essentially abstract painters, that the iconography was
not essential. In fact the link is generational, and it seems to be a fact that
preplanning and tidy execution, as a result of Johns' and Stella's influence,
were taken up as ways to refute the free-work methods of de Kooning and
Pollock. Pop art in the United States, more than elsewhere in the world, is a
learned and physically exacting style, partly because it had to measure up to
and survive the competition of peer group rivals in other styles. In retrospect,
it is extraordinary that recognition of the complex formality and sensuality of
Pop art should have been so long delayed by the supposed banality of the
subject. High style and low subjects, as it is now easier to see, are combined
in American Pop art, and neither term can be removed without damage to the
artists' achievements. The words in Johns do have a meaning, though not a
simple one; the images in Rauschenberg have iconographical connections,
though not causal ones, as we shall see

Pop art is a cluster, not a point, but it will always include at least one of the
following characteristics. (It is not to be expected that any single artist will
contribute to each category or that one category will apply to all the artists
equally.) The variables are syntactic complexity, range or extension of media,
familiarity of subject matter or literal presence of the object, and connections
with technology.

1. Syntactic complexity: under this heading belong the interplay of writ-
 ten and pictorial forms, such as Johns' letters, numerals, or words, and
 Indiana's numbers and sentences.
2. Range of media: Rauschenberg's combine-paintings (which relate to
 assemblage and to Happenings in their incorporation of diverse ob-
 jects); extension of medium, as in the case of Rosenquist introducing
 billboard techniques into experimental easel painting.
3. Familiarity of subjects: (Lichtenstein's comics or Warhol's newsprint
 sources); the literal presence of the object (Wesselmann's bathrooms
 and Dine's objects attached to canvases).
4. Connections with technology: Rauschenberg in particular, but ma-
 chines are also an essential term of Oldenburg's metamorphic forms.

However, given these points of reference, there is considerable diversity of
individual usage. For example, Johns' combination of words and painting seem
intended to prompt doubt about our fallible systems of classifying information,
whereas Indiana's emblems act more like hex signs, that is to say, as assertions
of a desire for order and control. Warhol believes in repetition (*Thirty Are Bet-
ter Than One*, to quote a picture title of his), whereas Lichtenstein believes in
progression, the advancement of his sets of images from one point to the next.
These pairs make it clear that the Pop artists shared some common topics but

19

that they were never a unified group. There are no manifestos that all, or even a few, signed. Oldenburg and Dine began in and have retained an essentially expressionistic style. Warhol and Lichtenstein, in different ways, work without visible passion, keeping the touch of the artist low in profile, unlike Rauschenberg, whose escalated collages and photographic silk screens depend on his visual flair for placement and for accommodating one form to another.

Another way to approach a definition of Pop art is by considering artists who are not, in my opinion, essentially related to it, such as George Segal, Wayne Thiebaud, and Larry Rivers. Segal had numerous social connections with Pop art, which make his typing in the 60s as a Pop artist understandable. He was a founding member of the Hansa Gallery with Allan Kaprow in 1952 and later showed at the Reuben Gallery[5] with Kaprow, Oldenburg, and Dine, the latter two coming there from the Judson Gallery which they had founded. The first Happening (Kaprow's *18 Happenings in 6 Parts*) was at the Reuben Gallery in 1959, followed by others by Red Grooms, Robert Whitman, Dine, and Oldenburg. In addition, Segal was linked to a number of artists who had converged on New Jersey. Kaprow writes: "Ironically Rutgers [University] was the catalyst in all this, in spite of itself. For the record, it never encouraged and often opposed, what we were doing . . . Watts originally came to teach engineering; I teach art history. Segal was a chicken farmer nearby; and Brecht in his inimitable way of seeming anonymous, chose to live in a split-level while working as a scientist for Johnson and Johnson Company."[6] In 1960, Lichtenstein joined the faculty at Douglass College, Rutgers University. Among the students who responded to this apparently accidental but potent group were Lucas Samaras and Robert Whitman. Robert Watts and George Brecht became associated with Fluxus, a group that produced object-based or environmental art, interests that were akin to those of Pop art, but which, in the absence of the traditional art format that Pop artists retained, became obscured and diffuse in the 60s.[7]

Lichtenstein has recorded that the environmental aspect of Happenings influenced him toward using common objects from daily life in his paintings. The expressionistic character of Segal's early paintings is a link to the turbulent surfaces of Oldenburg and Dine, but as his sculpture separated from his paintings, the emphasis shifted. Segal's figures are the outside of life casts, a process of work which parallels the quotations and the process abbreviation of Pop artists but, in effect, seems closer to realism. Formal connections with Edward Hopper or with Daumier in the end outweigh the links to his contemporaries. (Rothko is reported to have observed of Segal's *Gas Station* that it was a "walk-in-Hopper" and a comparable pathos emanates from the work of both artists.) Segal has a searching eye for revealing poses and occupational gestures, moments of common humanity, shrewdly observed and subjectively shared. Wayne Thiebaud was taken to be a Pop artist on the basis of his subject matter, namely mass-produced food on counters and shelves, under fluorescent lighting. However, the repetitions are not like Johns' numbers or Warhol's soup cans, standardized and flattened by the conventional nature of the sign-systems that they use. The wedges of pie, for example, are naturalistically varied, and

20

the parade lines they form are in perspective. The food paintings follow logically from Thiebaud's early still life subjects of trophy walls and tabletops, painted in a spiky, ornamental postwar School of Paris style. It is not hard to see Thiebaud now as a realist occupied by such stylistic problems as annexing De Stael's lush paint and adding it to an American subject matter. His later figure paintings and the subsequent development of realism make it clear that his allegiance is with realism rather than Pop art. Mel Ramos, who was influenced by him, realized a Pop art potential in his art that Thiebaud did not follow up, especially in Ramos' comic strip and girlie paintings. In both, Thiebaud's fat impasto is insinuated into directly popular imagery, at first quoted but later invented.

Pop art is a part of a wider predisposition toward the reintroduction of imagery and the use of quoted sources among the generation of artists that followed abstract expressionism. It was a mistake of the 60s to label every such indication according to the most conspicuous manifestation of this impulse, which was then Pop art. For instance, Larry Rivers' *George Washington Crossing the Delaware*, 1953, seems to have prompted a play of the same title by Kenneth Koch in 1955, for a production of which Alex Katz made standing cutout figures of revolutionary and redcoat soldiers.[8] Koch's text is written deliberately in clichés, but with an infantile naiveté that the clichés used by Pop artists rarely have. Katz's cutouts, painted with a subtle stylization, far in excess of the quality of the play, are also toylike. There is a nostalgic quality in both text and cutouts which is far removed from Pop art, which never used the low materials it quoted in a folkloric or nursery spirit.

Sam Hunter has written of Larry Rivers that "his particular angle of vision has been influential, although not perhaps decisive, in opening up to a younger generation a new range of overlooked subject matter."[9] Pop art tends, when depicting single objects and signs, to be emblematic and still, and when dealing in groups, to be repetitive (Warhol) or random (Rauschenberg). Rivers, on the contrary, employs a painterly gamut of atmospheric touches, taken in conjunction with a traditional system of compositional checks and balances by means of which a single image is always variegated and a complex one is graduated. According to Hunter, Rivers' first painting with the stars and stripes in it is earlier than Johns', but in the absence of formal or intentional convergence, it is hard to see that the comparison means much. In fact, Rivers is closer to Albert Gleizes[10] than to Johns, whose flags combine the tough literalness with the significative doubt of Pop art. Gleizes' *Astor Cup Race (Flags)*, 1915, shows the American flag prismatically broken, comparable to the way the flag is scenically treated in Rivers' painting.

Pop art, no matter what its interpreters have seen in it, can be ironic, as Johns is, but not humorous. Rivers, on the contrary, is an inveterate gag man. One point at which Rivers inarguably contributes to the Pop canon is in 1960 with three paintings of the new model Buick. The car is painted in long, low rectangular masses, giving the image of a Mark Rothko painting. The technological content and the levels of reference that conflate a car with an abstract painting have the locked balance of possible meanings characteristic of Pop.

21

15. Larry Rivers. *Buick Painting with P.* 1960. Oil on canvas. 42 x 54. Anonymous lender.

This deadpan attitude is not found elsewhere in Rivers. With the passing of time it is possible to see that *George Washington Crossing the Delaware*, belongs less with Lichtenstein's parodies than with later developments in the revival of history painting by realist painters.

Another artist who has often been assigned a place in Pop art is Marisol, but her art seems to belong elsewhere. She is a sophisticated naive sculptor whose figures possess a folkloric decoration and fantasy that is quite unlike Pop art. The habitual self-references in her work also suggest an introspection allied to compulsive artists like Lucas Samaras, whose content is drawn from their own personality. Samaras, after leaving Rutgers University, was a regular participant in Oldenburg's early Happenings, such as the season at the store, 1962. Samaras' own work of this period, shown at the Reuben Gallery, is object-based, but the autobiographical content is outside of Pop art.

2. SIGNS AND OBJECTS

When Pop art was recognized as a shared phenomenon there was hesitation as to what to call it. One term that was proposed was *New Realism*, based on an analogy between the Americans and the French movement promoted by Pierre Restany.[1] Another term was *Anti-Sensibility Painting*,[2] but the trouble with this is that much art, when it is new, seems to be anti-sensibility because it is unfamiliar. On the other hand, as it is accepted and learned, it becomes an extension of our sensibility and loses its adversary character. Hence this term proposes an absolute where there is none and is thus not workable. A third term, one that stressed an aspect of Pop subject matter, was *Common Object Art*.[3] Neither the term *New Realism* nor the term *Common Object Art* was retained, as we know now: the former was undesirable inasmuch as there were already several new realisms in existence, and it overemphasized the realist component in the art. On the other hand, though a little narrow, *Common Object Art* stressed the antiexotic and quotidian nature of Pop imagery.

It seems like a paradox that an art so closely based on the daily environment should in fact produce so few direct human images. When figures appear, as they do in Warhol or Rauschenberg they are mediated by photography: Lichtenstein's figures retain the symbolic character of their original function in war or romance comics, rather than a characterization originated by Lichtenstein; and Wesselmann's nudes are blank schemata animated only at the erogenous zones of mouth, nipple, and groin. At the time this absence of directly perceived and represented human figures was taken by expressionist or humanistic critics as evidence of cool detachment and indifference. There had been for some years a theoretical program to return art to the human figure as important subject matter, and it was a disappointment to its backers when Pop art, instead of an expressionist revival, developed.[4] Not only was the human figure not a dominant feature of Pop art, there were formal corres-

24

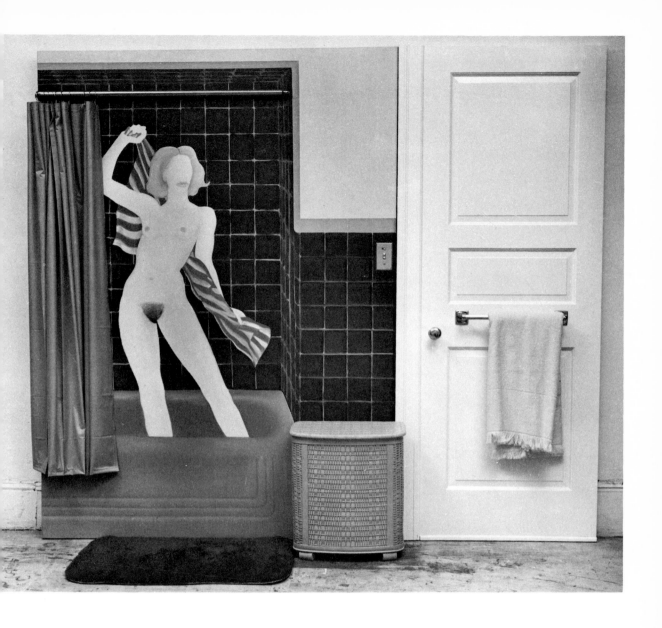

16. Tom Wesselmann. *Bathtub Nude Number 3.* 1963. Mixed Media. 84 x 106 x 17¾. Collection of Peter Ludwig, Wallraf-Richartz Museum, Cologne, West Germany.

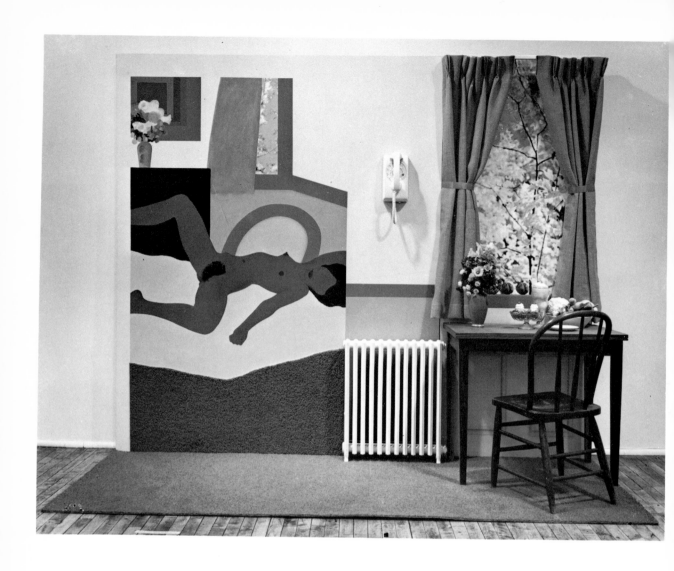

17. Tom Wesselmann. *Great American Nude Number 54.* 1964. Mixed Media. 84½ x 102⅓ x 52⅓. Collection of Peter Ludwig, Neue Galerie, Aachen, West Germany.

26

18. Richard Artschwager. *Portrait I.* 1962. Mixed Media. 74 x 26 x 12.
Collection of Galerie Neuendorf, Hamburg, West Germany.

19. Joe Goode. *Staircase.* 1970. Mixed media. 48 x 71 x 48. Collection of the artist.

20. Joe Goode. *Staircase.* 1970. Mixed media. 96 x 97 x 8⅞. Collection of Ron Cooper, Venice, California.

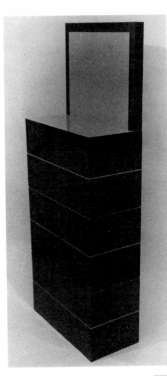

21. Richard Artschwager. *Portrait II.* 1964. Formica on wood frame. 68⅝ x 26⅜ x 12¾. Collection of the artist.

22. Richard Artschwager. *Table and Chair.* 1963–1964. Formica on wood frame. 54 x 55 x 25. Collection of the artist.

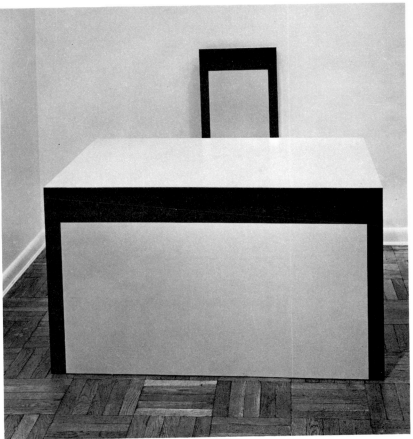

23. Billy Al Bengston. *Carburetor I.* 1961. Oil on canvas. 36 x 34. Collection of Artist Studio, Venice, California.

24. Billy Al Bengston. *Gas Tank & Tachometer II.* 1961. Oil on canvas. 42 x 40. Collection of Edward Ruscha, Los Angeles, California.

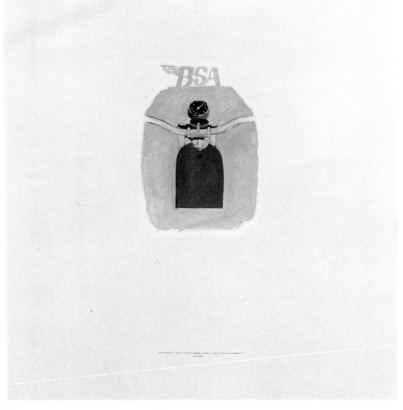

25. Billy Al Bengston. *Ideal Exhaust.* 1961. Oil on canvas. 42 x 40. Collection of Artist Studio, Venice, California.

26. Billy Al Bengston. *Skinny's 21.* 1961. Oil on canvas. 42 x 40. Collection of Dr. and Mrs. Mac L. Sherwood, Beverly Hills, California.

pondences to be detected between the tidier Pop artists and the systematically planned abstract paintings of the same generation. And beyond that there is a connection between Stella's so-called nonrelational painting of the late 50s and Johns' early work, as well as with Warhol's rows of repeated images.

However, objects of human design, manufacture, and use are by no means alienated from us. Indeed, the human presence is implied—given obliquely—by the objects: function, use, and familiarity are cues of human value. Richard Artschwager, who was a furniture manufacturer, has acute observations to make about the relationship of man and object. As he points out, "pieces of furniture are close to the human scale. This gives furniture a human quality."[5] The anthropometric character of such objects raises many analogies to the body. He expands on this theme as follows: "Furniture in its largest sense is an object which celebrates something that people do—or sanctifies it. Celebrate is a better word."[6] Artschwager remembered that he "started doing some work for a Catholic church. I made altars. I must have made thirty shipboard altars over about a year's time—portable altars with all kinds of brass fittings. . . . I was making something that, by definition, is more important than tables or chairs—that is, an object which celebrates something."[7] Thus Artschwager's objects, which are like monuments to furniture—a chest of drawers as a frozen mass, a table as a solid block—allude to human use and scale, even as the regular functions, of storage or support, are suspended. It is a subtle mixture of the actual and the fictional, of presence and absence. Lichtenstein's single-image pictures, in which an enlarged object (a golf ball, a tire, an ice-cream soda) is painted systematically, are comparable in their monolithic isolation.

Artschwager's allusive objects and Lichtenstein's signs for objects seem to combine two levels of meaning. On one hand, the human presence can be inferred; on the other hand, the indirectness of such references permits us to feel these objects in another way. For instance, Barbara Novak has suggested that "the still life in its indifference and monumental inertia, represents existence 'out there.' . . ."[8] Such an impulse to objectivize the products of man, and thus cut down on the subjectivity of the artist, is understandable of the generation that followed abstract expressionism. The gestural style of Pollock, the expressionism of de Kooning or Kline, and the seer-like attitudes of Newman and Rothko were not the means by which the younger artists wanted to produce art. The factual definition of signs and objects, however, presented a possible mode of work that was ironically distanced. The human traces are there, but implied and not insistent, and characterized by some deception, as when Warhol and Lichtenstein conceal their originality behind acts of unilateral collaboration with unknown and absent image-makers. To quote Novak again: "much American art of the late eighteenth century and of the nineteenth century can in fact be seen as still life, whether a portrait by Copley or a landscape by Lane."[9] This factual American gaze is found again in Pop art. Billy Al Bengston's series of paintings of a BSA motorcycle, the whole and its parts, is a good example of a precise viewing of a technological subject. The pictures are close to Bengston's life inasmuch as he was a rider. A technical

27. Jim Dine. *Four Rooms*. 1962. Oil on canvas, metal, rubber, and up-
holstered chair. 72 x 180. Collection of Sonnabend Gallery, New York.

28. Jim Dine. *Tie Tie*. 1961. Oil on canvas. 70 x 70. Michael Cullen Gallery.

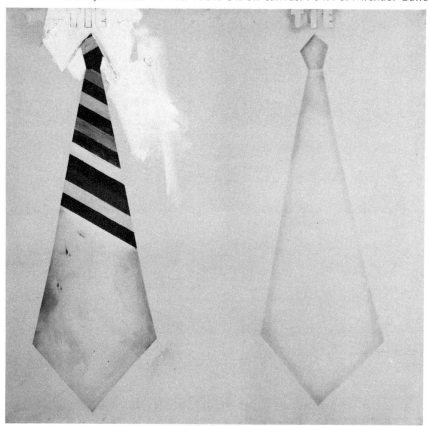

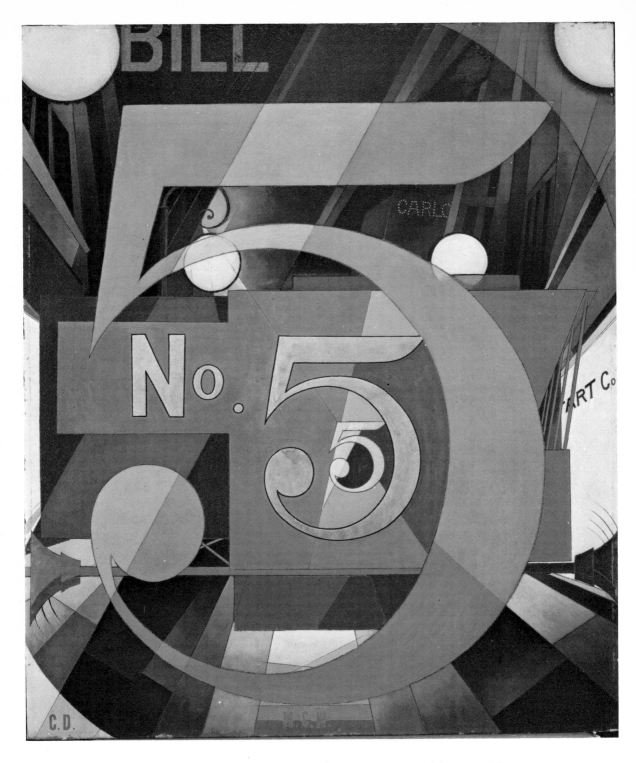

29. Charles Demuth. *I Saw the Figure 5 in Gold.* 1928. Oil on canvas.
Metropolitan Museum of Art, The Alfred Stieglitz Collection, New York.

Plate 3. Edward Ruscha. *Noise, Pencil, Broken Pencil, Cheap Western.* Oil and collage on canvas. Collection of Locksley-Shea Gallery, Minneapolis, Minnesota.

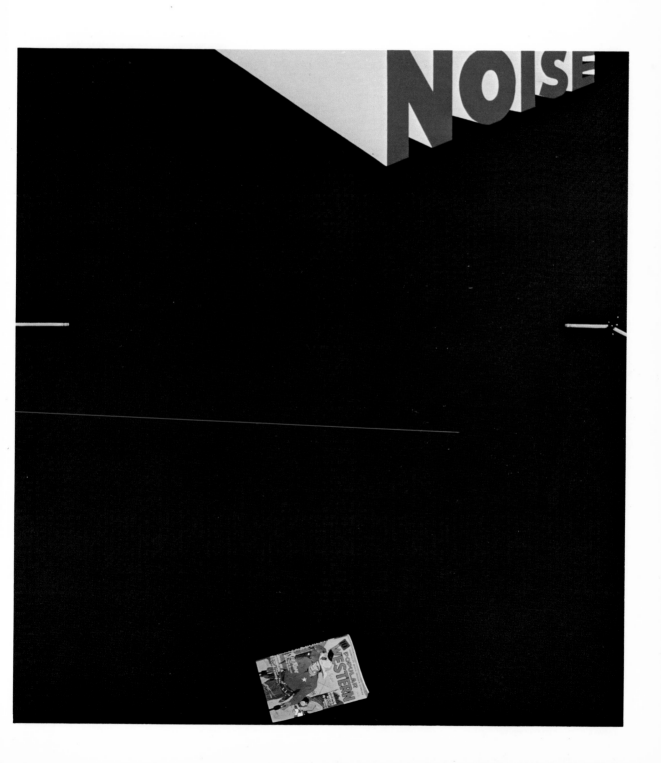

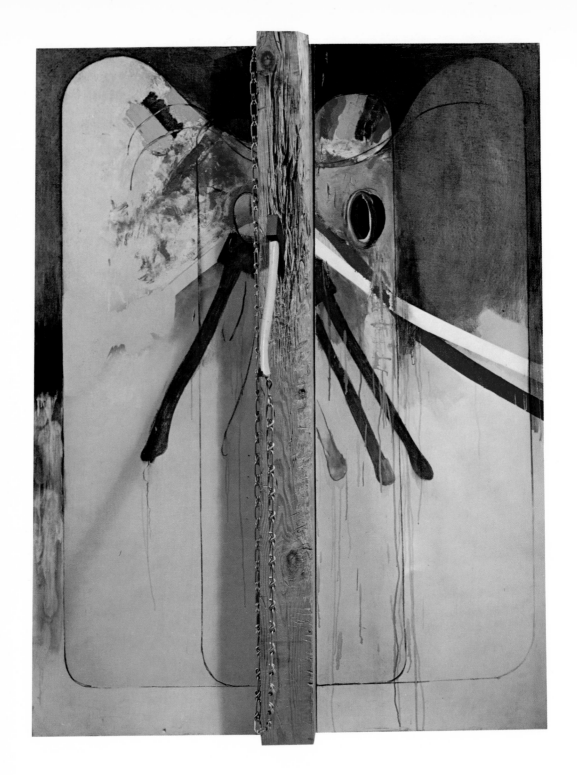

Plate 4. Jim Dine. *Hatchet with Two Palettes, State No. 2.* 1963. Oil on canvas with wood and metal. 72 x 54 x 12. Collection of Harry N. Abrams family, New York.

journal describes how he has used in his paintings ". . . such items as the license plate, the BSA nameplate in several different interpretations and the cylinder head, complete right down to the pink spark plug insulator (a Lodge exclusive feature)."[10]

In 1961, Dine made a group of paintings which carry the image of an object and its description: *An Animal* (a fur rug), *Blonde Hair* (yellow paint), *Hair* (calligraphy), *Shoe* (a two-tone shoe), *The Red Bandana* (a red bandana), and *Tie Tie* (two neckties). Unlike Magritte, who would paint object "A" and caption it "B," Dine's legible image is described accurately, even where, as in *An Animal* and *Hair*, there is metaphor. Instead of feeling the redundancy of this pairing of word and image, one becomes aware, in Dine's focus on name and thing, of the differences between signifier and signified. We can take the image as the real thing, because it is more iconic and physically like the subject, in which case the word is a conventional sign for it. Or, since neither image nor word is, in fact, a shoe or a tie, we can interpret the painting as two signs of an absent object. Dine does not aim for paradox, as Johns does, but for all the materiality of his images, which imply a kind of naturalistic relish of the objects of experience, the mystery about what is signified is not dispelled. He is not seeking doubt, but he shows doubt to be a natural state; for all the emphatic ripeness of his painting, the signs he uses are not entirely fixed. The paradox is that the literalness of Dine's objects is not reduced by their problematic status. That these multi-levels of reference were intended by Dine is clear from his subsequent work, such as *Four Rooms*, 1962, in which four canvases are turned into walls by means of a rod for a shower curtain on one of the canvases and by the presence of a real armchair in front of another.

The complexity of visual signs, as well as the difference between verbal and visual forms, is also the theme of *Numbers*, a collaboration by Indiana and Robert Creeley.[11] Serigraphs and poems on the numbers *one* through *nine* to *zero* are paired. In each print there is both the numeral and the word for it, which introduces a double level of signification. By comparison with the images, however, the poems seem diffuse with references to many subjects. "The / table stands on / all fours. The dog / walks comfortably / and two by two / is not an army / but friends who live. . . ."[12] By comparison, the stillness of the colored numerals is monumental, undistracted by specific cases, though the numbers' implicit connection with human acts of grouping and ordering is unbreakable. Indiana's quotation of Demuth's *I Saw the Figure 5 in Gold* was reinforced for him by the fact that it was painted in the year of his birth, 1928. He adds that he made *The Demuth American Dream*, and other paintings from the *5* in 1963 "which when subtracted by 1928 leaves 35—a number suggested by the succession of three fives (555) describing the sudden progression of the firetruck in the poet's experience."[13] Thus out of the use of quotidian material, which our numbering system certainly is, Indiana achieves both a formally taut and an evocative imagery.

Ed Ruscha took as his starting point Jasper Johns' *Tennyson*, 1958, one of the first paintings in which a word is used as an object. *Tango*, 1955, is earlier,

35

but there is a slippery reference here to a fractured carol which plays when a little key is turned in the face of the picture. *Tennyson*, however, carries no such justification: the word runs in stable capital letters across the lower zone of the picture. The name is known, but not the reason for its appearance here. Does Johns like Tennyson's poetry, or is he using the name to refer to an artist whose effusive and emotional nature is polar to Johns' own? Is it Tennyson instead of William Carlos Williams? There is no reason to choose one of these meanings, but we can determine this: it is a painting of a word, and the word is a poet's name; therefore the picture, in its enigmatic fashion, is an example of *Ut pictura poesis* ("as in painting, so in poetry"). This phrase of Horace's refers to the tradition in which poets write pictorially and in which artists paint verbally-based subjects.[14] In Pop art, it can be taken to refer to the coexistence of visual and verbal signs. We are accustomed to words delivering meanings, but Ruscha's vocabulary consists mostly of single words, without syntax and without context. Thus they resist linguistic interpretation and occupy the paintings like objects, though equivocal ones.

Consider a group of 1962 paintings by Ruscha: in *Ace*, the word is poised above a Rothko-esque block of color; *Radio* is a yellow word on gray; *Honk* is pale blue on soft gray (and thus definitely non-onomatapoeic); *Noise* is yellow on blue, tranquil in effect, despite the sense of the word; and *Fisk* is white on green, with a small image of a tire. It is not that its words are without

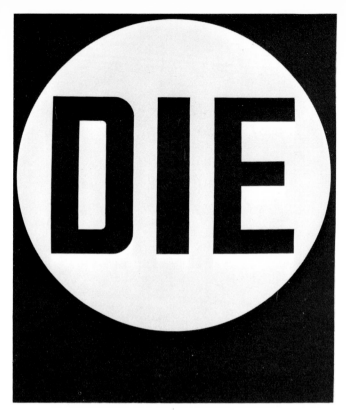

30. Robert Indiana. *Eat/Die*. 1962. Oil on canvas. Two paintings, each 72 x 60. Collection of the artist.

meaning, because we recognize them and read them, but we are conscious that the words are numbed, their usual functions held in suspense. Thus the work, in sum, represents a kind of willed muteness. Ruscha is a graphic designer (responsible for the layout of *Artforum* in the 60s under the name, Eddie Russia), and his pleasure in type faces is clear. To quote the artist: "advertising influenced me, typography influenced me."[15] Certainly his signs resemble, in their legibility and impact, the logos and names that are abundant in the urban environment—especially Los Angeles where Ruscha lives, but normal everywhere. They are deceptively obvious, common words monumentalized by the act of painting. He cuts down symbolism but retains as his subject forms that exist only for purposes of communication, words. The compound of literalness and a play with evocative form is characteristic of Pop art's ambiguity, to some, its perversity. *Annie*, 1962: *Little Orphan Annie*, Annie Laurie, *Annie Get Your Gun*, a girl friend? Four years later, he painted *Annie Poured from Maple Syrup*, one of the "liquid pictures" of the mid-60s. The type is the same, but the format is horizontal instead of upright, as earlier, and the word is painted to simulate poured characters in viscous liquid. Little splashes and irregularities of surface tension are scrupulously painted. Common words become cryptic in the clear light of day without any mystification. Later paintings of 1964, such as *Damage*, a word on fire, and *Hurting the Word Radio*, in which the letters are stretched and distorted, testify to Ruscha's conscious definition of words as objects.

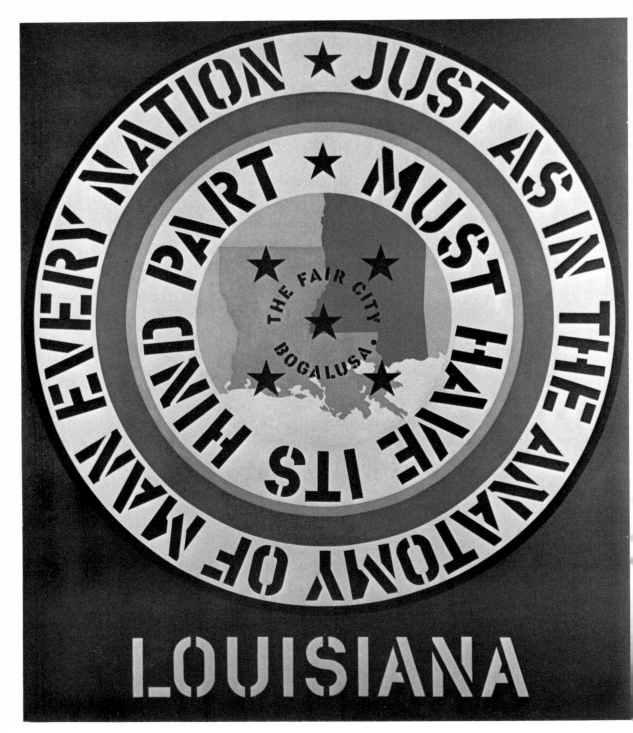

31. Robert Indiana. *Louisiana.* 1966. Oil on canvas. 70 x 60. Collection of Krannert Art Gallery, University of Illinois, Champaign, Illinois.

32. Jasper Johns. *Tango.* 1955. Encaustic on canvas with music box. 43 x 55. Collection of Mr. and Mrs. Burton Tremaine, Meriden, Connecticut.

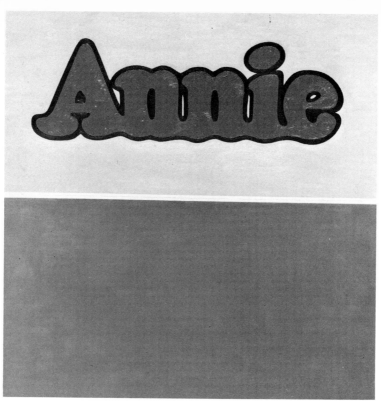

33. Edward Ruscha. *Annie.* 1962. Oil on canvas. 71 x 66½. Private collection, Los Angeles, California.

34. Edward Ruscha. *Annie, Poured from Maple Syrup.* 1966. Oil on canvas. 55 x 59. Collection of Pasadena Museum of Modern Art, Pasadena, California; Gift of the Women's Committee.

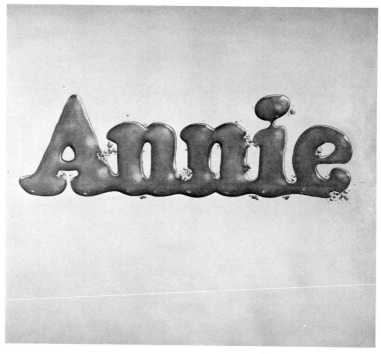

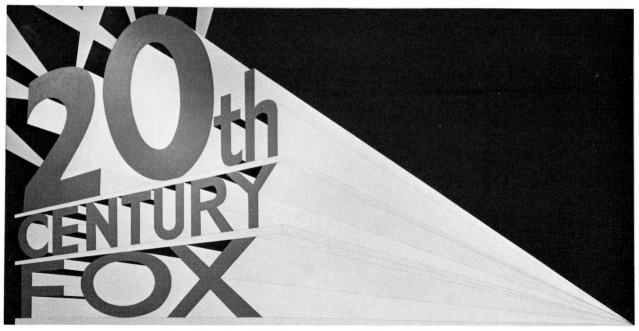

35. Edward Ruscha. *20th Century Fox with Searchlights.* 1961. Oil on canvas. 67½ x 133¾. Collection of Stephen Mazoh and Co., Inc., New York.

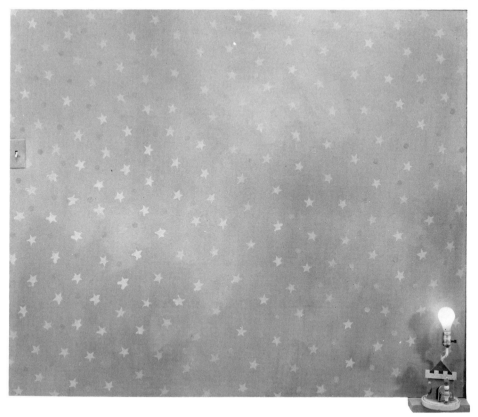

36. Jim Dine. *Child's Blue Wall.* 1962. Oil, wood, metal, light bulb. 60 x 72. Collection of Albright-Knox Art Gallery, Buffalo, New York; Gift of Seymour H. Knox.

In the catalog of *Art 1963—A New Vocabulary*[16] several definitions of topical words are given. There is *Environment*, "the aggregate of surrounding things, conditions or influences"; another is *Fact*, "Fact n., the American tradition"; and third, *Object*, "in this art movement a word signifying concern for 'things'." And from the same useful source a quotation from Jim Dine: "My paintings are involved with 'objects'. At a time when the consumption of same is so enormous I find the most effective picture of them to be not a transformation or romantic distortion but a straight smack right there attitude. I am interested in their own presence."[17] These words—*environment*, *fact*, and *object*—are all relevant in discussing Pop art: to some extent, anybody that we call a Pop artist touches on these terms. The emphasis on real, found, and manufactured objects, for example, compared to the sole reality of the work of art itself in abstract painting is certainly intended. As things from the world show up in Pop art, it is like sand thrown into the smoothly working machine of abstract artists. The formal mechanics of abstraction grind to a halt around the obtrusive object. The abstract expressionists, in their large pictures and in their interest in unitary groups of paintings, extended their works into environment. The word *environment* persisted, but its meaning changed to refer to the world out there—the world around, as a source for the artist. Oldenburg, for instance, conceives his development as a series of environmental steps: from the street to the store to the room and, in his monumental sculpture proposals, to the scale of the city itself. The stress on fact can be verified by a list of the quoted signs and the appropriated objects within Pop art. However, for all the solidity of these terms, it is true that Pop art is not just a form of realism. Possibly one reason for this is the artists' transformation of their predecessors, the abstract expressionists: among them the idea of improvisation, of making up the painting as one works, gave intensity and uncertainty to the creative act itself. In Pop art, however, the creative act, though flexible and including improvisational possibilities, is more planned and prestructured. The idea of process (concentrated on the creative act by the abstract painters) is displaced to the end result of the act, to the work of art itself, where it functions as a kind of mobility of signification.

There is some reason to think this is so, inasmuch as almost no artist would be willing to describe his actions as bound by a closed system; the sense of process, of organic changes is implanted. The rejection of abstract expressionism does not, therefore, mean the abolition of process, as some early critics of Pop art assumed. However, the question of how it was possible for a diverse group of artists, starting from separated points, to arrive at this idea of flowing rather than arrested meaning must be answered. The answer may be found in the interest of all these artists in the twentieth-century communications network of which we are all a part, but which Pop art, in particular, has taken as subject matter. We inhabit a complex communications system and use a multitude of objects that are defined verbally and visually as well as physically. Perhaps the situation can be described by reference to Kierkegaard's *The Present Age*, which is still, in some respects, our age. "A revolutionary age is an age of action; ours is the age of advertisement and publicity. Nothing ever happens

37. Jim Dine. *Two Palettes (International Congress of Constructivists and Dadaists, 1922).* 1963. Oil on canvas with collage. 72 x 72. Collection of A. I. Sherr, New York.

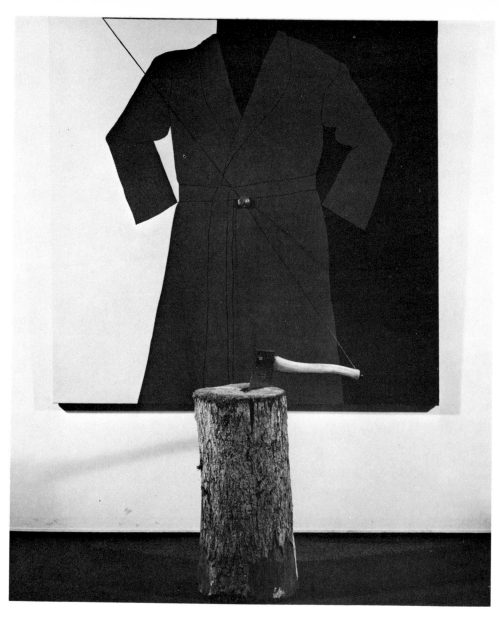

38. Jim Dine. *Red Robe with Hatchet (Self-Portrait)*. 1964. Oil on canvas with metal and wood. 60 x 60 x 23. Collection of Mr. and Mrs. Sydney Lewis, Richmond, Virginia.

39. Claes Oldenburg. *The Street*. Mixed media. Variable size. The Reuben Gallery, 1960.

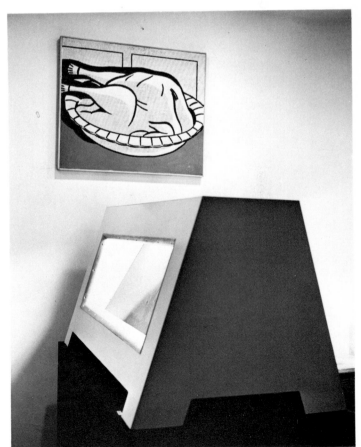

40. "The American Supermarket": Roy Lichtenstein, *Turkey*, 1961; and a simulated Richard Artschwager, *Freezer*. The Beanchini Gallery, 1964.

41. Andy Warhol exhibition. 32 paintings. 16 x 20. The Ferus Gallery, 1962.

42. Tom Wesselmann. *Still Life, 20.* 1962. Mixed Media. 48 x 48. Albright-Knox Art Gallery, Buffalo, New York; Gift of Seymour H. Knox.

but there is immediate publicity everywhere."[18] "Everything is transformed into representative ideas." He takes money as an example: it, too, is "only representative, an abstraction . . . one longs for the clink of real money after the crackle of bank-notes."[19] With the increase of newspapers, journals, and books in the nineteenth century, with the development of a distribution system (for goods and for travel), with the growth of banking; so various sign-systems, from advertising to complex forms of accounting, defined man's urban activities in a web of symbols. Words and images do not merely represent things but have their own properties, which meant that as the system got more complex, discontinuities between signifiers and signifieds mounted. The more we live in an "age of advertisement and publicity," the more chances there are to become aware of the deceptiveness of signs and the solidity of symbols that obscure their original referents. This is why Kierkegaard judges that a revolutionary but too reflective age "leaves everything standing but cunningly empties it of significance."[20]

The attitude of the Pop artists toward the signs and objects that they use is neither one of simple acclaim, celebrating consumer goods, nor of satirical condemnation of the system in favor of some humanistic norm of conduct. On the contrary, they use the objects of the man-made environment with a sense of meaning in process, an experience based on the proliferation and inter-penetration of our sign- and symbol-packed culture. The mass media contribute not only to our entertainment but also enlighten us regarding the provisional nature of all communication. Thus the inimitable play within Pop art of the colloquial and the typical, on one side, and the evasive and the estranged, on the other. It has often been said by critics committed to a nineteenth-century idea of realism, as lessons in the observation of humble life, that Pop art shows us Pop culture, that Roy Lichtenstein leads us back to the comics refreshed. If this were all, it would be a poor return for the attention given to Pop art. What the Pop artist does is to take standard everyday material, familiar to his audience, and reveal clearly the changes made by the artist, thus declaring the mobility of signs, their multiple uses, in a way that distressed Kierkegaard, but which we can see as accurate in our experience. It is not simply our experience of comic strips or logos, of billboards or Campbell's Soup cans, in isolation, but of human communication as a sytsem—unreliable and inescapable.

References to art in works of art can take one of two forms: citing other people's art, or cross-referencing a single work by an artist and other works by the same man. Ed Ruscha's two versions of *Annie* constitute the latter form, as do John's repetitions of paintings in prints. Wesselmann includes unmistakable references to later Matisse, especially the Barnes murals, in his Great American Nude series, so that collage from Pop culture and allusion to art coexists on equal terms. Rauschenberg has used in his silk-screened paintings two images of Venus and Cupid, one by Velasquez and one by Rubens. In both Cupid holds a mirror up for Venus, who is seen from the back. These are almost the only quotations of past art in Rauschenberg's paintings, and their similarity suggests intentionality in the choice. Lichtenstein's references to art

47

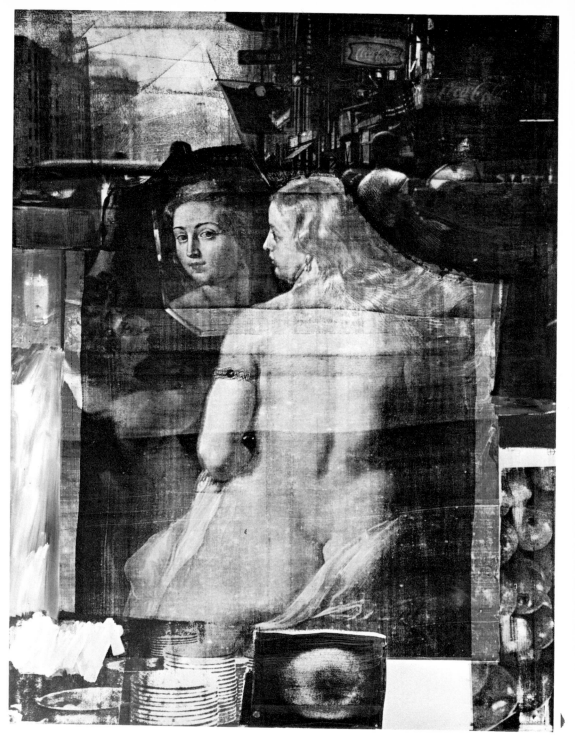

43. Robert Rauschenberg. *Persimmon.* 1964. Oil on canvas with silk
screen. 66 x 50. Collection of Mr. and Mrs. Leo Castelli, New York.

44. Robert Rauschenberg. *Trapeze.* 1964. Oil on canvas with silk screen. 120 x 48. Collection of Galerie de Sperone, Turin, Italy.

45. Tom Wesselmann. *Great American Nude 26*. 1962. Oil and collage on canvas. 48 x 60. Collection of Mr. and Mrs. Robert B. Mayer, Winnetka, Illinois.

constitute a basic theme of his art, either in terms of specific artists, such as Picasso, or of period styles, such as Art Deco.

Oldenburg's use of art is part of his impulse to multiply meanings wherever possible. He has written of "a plan to redo the *Sleeping Muse* as a soft sculpture in the form of a teardrop type automatic headlight."[21] Another Brancusi allusion is contained in his note of a fire plug's resemblance to Brancusi's *Torso of a Boy*, as well as to "the widely separated breasts of Michelangelo's *Night and Day* [sic]."[22] Oldenburg proposed a monument of Mayor Daly for the artist's native Chicago, in the form of a decapitated head. "I was thinking of giant toppled Mexican heads on Easter Island, all the fallen heads of archaeology, and of Brancusi's 'egg' (headlight)."[23] Referring to a projected sculpture of paste being ejected from a stepped-on tube, Oldenburg compares the spurt of paste to "the upreaching hand as culmination of a thrusting form, as in a figurehead in some version of *Europa and the Bull*."[24] The reference is certainly to Titian's *Europa* in the Isabella Gardner Museum. It is part of Oldenburg's copiousness that he can evoke simultaneously the iconography of humanistic art and, say, the highway culture of the U.S., in which whole buildings function as signs, like the Brown Derby in Los Angeles or the Leaning Tower of Pizza in New Jersey.

3. ARTISTS

Jasper Johns and Robert Rauschenberg

Between about 1955 and 1960, Jasper Johns and Robert Rauschenberg were in constant communication, sharing a studio, and as the first and best audience of each other's art, they gave one another "the permission to do what we wanted."[1] A decade later, both have a kind of proto-Pop art eminence. They are the only painters that John Cage has written about, and like him, they are both friends of Merce Cunningham. Writing about Johns, Cage said: "The situation must be Yes-and-No, not either-or. *Avoid a polar situation.*"[2] The italicized sentence is Johns' and an appropriate warning. The differences between the two artists are as interesting as the connections, but their dissimilarities should not be presumed to be exemplary (like Northern Man versus Mediterranean Man, say). They do not represent cultural alternatives in the way that Poussin and Rubens, Delacroix and Ingres, are supposed to do.

Johns' art is predicated on ambiguity, that of Rauschenberg on heterogeneity. The mixture of objects in Rauschenberg's combine-paintings and of photographs in his silk-screened paintings testify to his interest in scattered sources and, also, in process abbreviation. His working method is to deal, as far as possible, with whole forms, which involves reducing the number of procedures by which the work of art is constructed. In the combines he tended to use objects unchanged, so that the original function of the hardware remained clear within the completed work. The silk-screened paintings are the result of combinations of ready-made complete images printed, all-in-one, on the canvas. The integrity of the found status of both object and photograph is carefully preserved as the constituents of his heterogeneity.

Rauschenberg avoids engagement in a prolonged series of operations (from sketching to drawings to painting, say, or the preparations for casting) and works in ways that deliver legible results at an early point in the work process.

52

Then he can modify the cluster of found images, working from a whole, as in the *Erased de Kooning Drawing*, 1953, in which he certainly began with a whole. The result is that the final works, though unified visually because he handles placing and junctures with great fluency, retain a certain separateness of the parts. It is essential to his aesthetic that this heterogeneity be preserved. He has written: "With sound scale and insistency trucks mobilize words and broadside our culture by a combination of law and local motivation which produces an extremely complex random order that cannot be described as accidental."[3]

Rauschenberg deals, then, with a profusion of objects and events that he can accept within a capacious aesthetic. Johns, on the contrary, does not take an optimistic pleasure in the connectivity that random events generate. Rauschenberg celebrates the abundance and mobility of twentieth-century life in a way that affiliates him with Italian futurism and El Lissitsky's kind of constructivism (more industrialized than idealistic in Gabo's manner, that is to say). If Rauschenberg is the type of artist as radar operator, Johns is the artist as textual scholar, appraising unreliable symbols. Johns is responsive to the ambiguity and disturbance latent in all sign-systems and has intensified this awareness until it is a main subject of his work. There is a traditional argument about signs and the extent to which they are transparent (serving only to point to their referent) and the extent to which they become veils (when a sign-user is infatuated with their substance). Johns has taken signs of extreme banality and painted them with an exquisite regard for their artistic characterization, so that we are unsure if we are seeing through them to the sign or being distracted (i.e., pleased) by the veil.

Random order cannot be well described by means of terms that have to do with protracted process or causal iconography. We might regard Rauschenberg's works as in the nature of conglomerates—the geological term referring to a mass of heterogeneous materials, applied recently to companies whose acquisitions have a nonmonopolistic diversity. Whereas Rauschenberg celebrates chance in terms of a permissive aesthetic, Johns is concerned with the irreducible presence of doubt in a strict aesthetic keyed to the subtleties of easel painting and traditional graphics.

Johns' imagery is characteristically monolithic—with a massive central object —or serial, as in the parades of alphabets or numbers. Rauschenberg's work is more like an open field, with a cluster of points of equivalent interest distributed like islands. Where Rauschenberg accepts the abundance which jumps fully formed from society's head, Johns is elegiac or memorial, commemorating words like *The*, *Tango*, or *Tennyson*. Rauschenberg's art samples a plenty that includes both the sensory input of the city dweller and the industrial output of material goods and waste. Johns' art is concerned with subtle minimums, laconic in style and sceptical in timing. He is concerned with stress, the limits of communication, the points at which translatability and autonomy collide. Rauschenberg's early work is a spectacle of unpredictability, whereas his later work is eloquent on the basis of a greater probability of image than in his days of maximum heterogeneity. Johns' later work, however, has expanded with an unexpected thrust in a new direction.

53

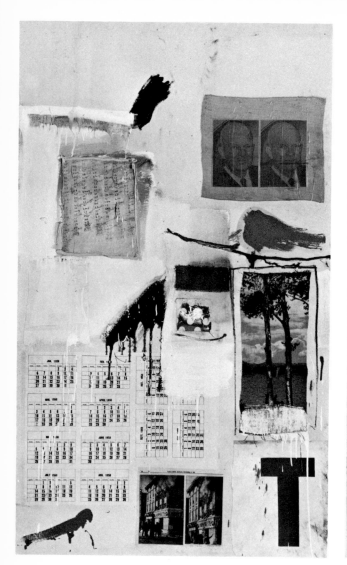

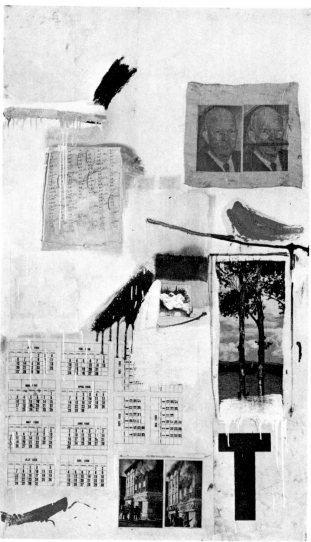

46. Robert Rauschenberg. *Factum I.* 1957. Oil and collage on canvas. 61¼ x 35¾. Collection of Mr. and Mrs. Morton G. Neumann, Chicago, Illinois.

47. Robert Rauschenberg. *Factum II.* 1957. Oil and collage on canvas. 61¼ x 35¾. Collection of Count Panza di Biumo, Milan, Italy.

Factum I and *II*, 1957, together constitute a rare occasion in Rauschenberg's work in which the naturalistic celebration of diversity by means of common urban materials is abated, and he is involved with the syntactics of art in a way akin to Johns. The two works are as alike as handmade execution can reasonably get them, without one of the works becoming a forgery of the other: the photographs are doubled up and so is the brushwork (slashes with a full brush, trickles of paint). The pair of paintings has been interpreted as a manifesto against abstract expressionism (the source of Rauschenberg's own emphatic brushwork), in the later phase of which autographic brushwork had become standardized. The pair can also be considered as clearly Rauschenbergian in its interplay of the reproductive image and personal touch, which is achieved in another way in the later silk-screened paintings and lithographs.

If the *Factum* pair is Rauschenberg's Johns, *Alley Oop*, 1958, I suppose, is Johns' Rauschenberg (at least it belongs to Rauschenberg). It is not a completely characteristic Johns, but it has an irreducible Johnsian character that is worth indicating. In *Alley Oop*, there is a painterly top-dressing on the original comic strip, but the pleasant licks of paint do not obliterate the narrative sequence of the original. Though not readable as a specific episode, the panels are preserved, and there is a clear presumption of continuity, though at an abstracted level. The placing of the block of panels high in a field of color is reminiscent of *Flag on Orange Field*, painted in the preceding year, in which the pattern of stars and stripes is almost homologous to the dots and dashes in which the comic strip is painted. The double image—in this case of comic strip and of painting, one clearly indicated, the other obviously present —is typical of Johns's work, though as a rule the relation of painting and source is more oblique and impacted.

According to Rauschenberg, "there is no reason not to consider the world as one gigantic painting,"[4] from which it follows that the kind of painting he does indicates the kind of a world he thinks there is. To him the world is something to incorporate in his art by means of an appetitive and enthusiastic embrace. He has collected junk and assembled it into works of art which are a composite of hardware and paint, for which he coined the term combine-painting. As part of his permissive and acquisitive impulse he used comics and photographs, especially in the form of grainy photographic reproductions, which, first as collage elements and later as printing traces, were deposited on paper and canvas. All this material is identifiable in terms of its origins as well as becoming part of the cluster that constitutes Rauschenberg's composition. The images have a rendezvous in each work but not a sequential or causal arrangement. He makes an open display of heterogeneous events in the world without reducing our easy access to abundance. His acquisitive zeal is offset by his nonchalance about possessions: anything will do, it seems.

To consider in more detail the kind of painting that the world is, let us list some of the incorporated material in works of different periods. In *Rebus*, 1953, three joined panels are spanned by a horizontal flow of images in the upper half of the picture, above a color spectrum, and interlaced with the exuberant painterly scrawls of a full brush. Read from left to right, the collage

48. Jasper Johns. *Alley Oop.* 1958. Oil and collage on board. 23 x 18. Collection of Robert Rauschenberg, New York.

49. Jasper Johns. *White Numbers.* 1959. Encaustic on canvas. 53¼ x 40. Collection of Mr. and Mrs. Victor W. Ganz, New York.

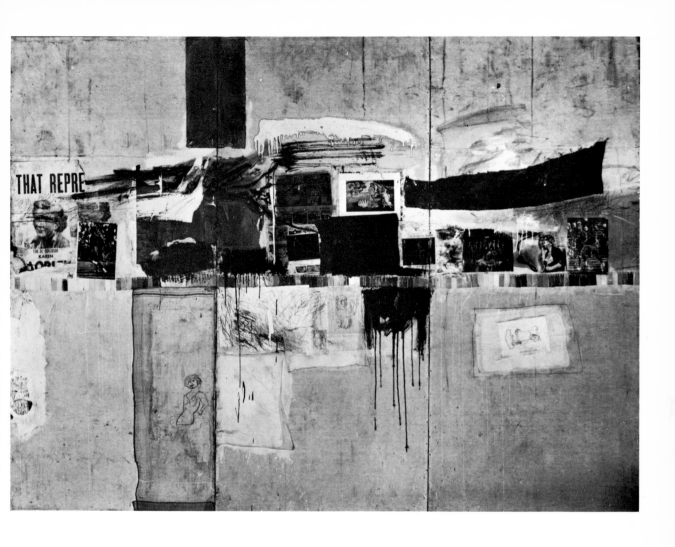

50. Robert Rauschenberg. *Rebus.* 1955. Combine-painting. 96 x 44. Collection of Mr. and Mrs. Victor W. Ganz, New York.

divulges two defaced political posters, a sports photograph of a runner, the word *Sun* from a yellow poster, colored comics from a Sunday supplement overlaid by a close-up enlargement of a mosquito and next to a color reproduction of Botticelli's *Birth of Venus*, and more. Another sports photograph and a patch of material conclude the sequence. The imagery is all grouped above the sustained but nuanced color samples; below the spectrum are drawings and scribbles, as well as dripped paint, and what looks like a graffito of a girl. Scribble and painting, high art and low art, hand-done and printed materials coalesce in a full hand of adjacencies and overlappings.

In *Charlene*, 1954, there is a marsh of newsprint, including comic strips and colored paper, torn and intermixed with splashed and dripped paint. Adjacent to this area is a neat, though slightly splashed, panel containing postcards and art reproductions: a Renaissance profile portrait, Degas, two van Goghs, Goya, Vermeer, Pieter de Hooch, and Renoir. Adjoining this, on the base line of the picture, is a postcard of the Statue of Liberty against the sunset. This is a partial list, but it is long enough to make the point that Rauschenberg's world includes images of high and low art, unified by an insistent tactility. The texture is that of use and of age, of downtown New York, say, or any city. It is physically analogous to the urban spectacle of waste and reuse out of which, in their commonness and repeatability, so many of Rauschenberg's objects and images derive. The waste is rescued for art, revived by recontextualization, but not wholly transformed.

Rebus is basically a painting, though combined with a crust of Junk Culture. *Odalisque*, 1955–58, is a free-standing object: in profile it is like a hobo's urn, improvised from bits and pieces, a central shaft thrust into a pillow. The architectural mass is combined with painting on the flat sides, where washes, smears, and splashes of paint veil or fuse the various photographs. These include a print of one of Rauschenberg's early works, *Nude Blueprint*, ca. 1950, and a nudist magazine photograph of two girls; hence, there are different kinds of body image, one personal and one impersonal, one unique and one mass-produced. It is not that Rauschenberg is preferring one to the other, but that he appreciates the rendezvous of divergent material. The selected pieces do not function in a cause-and-effect relationship, but as a simultaneous sample of the crowded world and the profuse media. The multiplicity itself is the primary subject. He has translated the design principle of the bulletin board into art: transient vivid imagery isolated by chance personal decisions from the flow of the printed media generate correspondences, once a certain point of complexity is reached. Every artist probably since World War II has used, at least for a time, a bulletin board, but Rauschenberg has made the endless play of chance images a principle of order.

Combine-paintings never looked new, and their construction was deliberately antiarchitectural. There are few new objects in them, the parts always being derived from waste lots, junk stores, and attics. Their beat-up appearance and their admixture of two- and three-dimensional forms perpetuate the dimension of waste. There is an analogy between these ramshackle hybrids and the building of ruins in the eighteenth century.[5] These ruins decorated

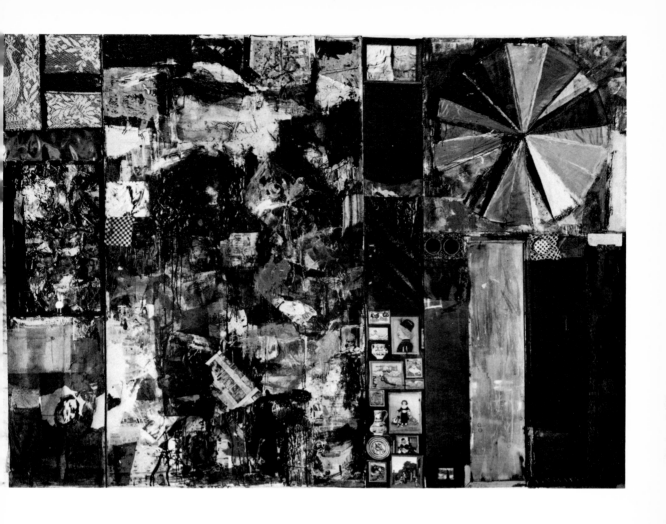

51. Robert Rauschenberg. *Charlene*. 1954. Combine-painting. 89 x 112. Collection of Stedelijk Museum, Amsterdam, The Netherlands.

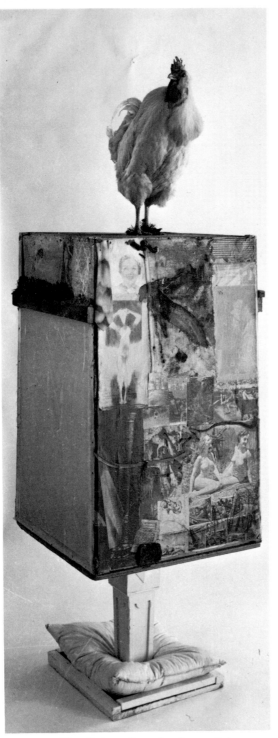

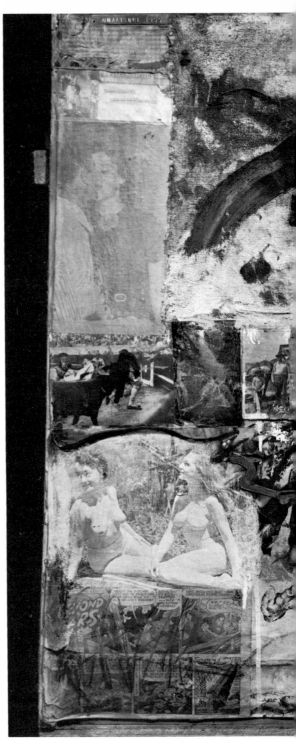

52. Robert Rauschenberg. *Odalisque.* 1955–56. Combine-painting. 81 x 25 x 25. Collection of Peter Ludwig, Wallraf-Richartz Museum, Cologne, West Germany.

53. Robert Rauschenberg. *Odalisque.* 1955–56 (detail).

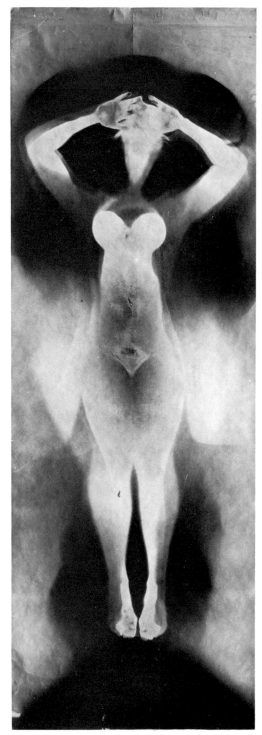

54. Robert Rauschenberg. *Nude Blue Print.* ca. 1949–50. Blue print paper. 105 x 36. Collection of the artist.

55. Robert Rauschenberg. *Bed.*
1959. Combine-painting. 74 x 32.
Collection of Mr. and Mrs. Leo
Castelli, New York.

56. Robert Rauschenberg. *Monogram*. 1959. Combine-painting.
48 x 72 x 72. Collection of Moderna Museet, Stockholm, Sweden.

formal gardens in the way that Rauschenberg's combines occupy museums. Ruins, constructed as such, raise a problem of classification: a (real) ruin documents the past and is usually in process of being reclaimed by nature. It is less separated from entropic processes and less artificial than a clearly demarked new building. Hence the *building* of a ruin initiates a complex relation of the work to time, simultaneously new and entropic. Similarly with Rauschenberg's combines: though newly-built, and in fact the product of topical aesthetic speculation, they dissolve the idea of finish into a structural and temporal situation of great complexity. Iconographically, a ruin can be considered as a "humble environment," a setting appropriately occupied by those who are close to nature. In a sense this is echoed by the antihierarchic and "democratic" form of order of the combines.

It is interesting to consider what it is that Rauschenberg liked about Leonardo da Vinci's *Annunciation* (Florence, Uffizi): "the tree, the rock, the Virgin, are all of the same importance in the same time. There is no hierarchy".[6] That is to say, Leonardo was like New York: Rauschenberg has recorded his pleasure "at being in a city where you have on one lot a forty-story building and right next to it, you have a little shack."[7] The first statement was made in 1961, the second four years later, but clearly the nonhierarchic aspect of the world has not lost its value to him. In fact, it applies no less to his later works, such as the silk-screened paintings that he began in 1962. He selected photographs, many derived from newspaper and magazine sources similar to those used in the combines, and others were taken by him (such as water towers against the evening sky). These were enlarged and transferred to silk-screens which Rauschenberg then used in combinatory sets, variously inked, to produce images that were at once documentary and hand-controlled. Iconic signs (physically similar to the object they describe) and autographic handling (pressures of the hand) are in balance. Typical screens represented: water towers, radar or radio bowls serviced by tiny figures, white-suited workers around a missile head, a swimmer, baseball players, mosquitos, a key, an army truck, a helicopter, a horserace, a stack of plates, calibrated dials, the Statue of Liberty, Velazquez's *Venus and Cupid*, etc. These images are compatible with, but extended from the early collage material; in place of the gritty, "humble" urbanity there is a greater stress on technology. That the shift was central to Rauschenberg is suggested by the escalation of technological imagery in his series of lithographs, *Stoned Moon*, 1969, derived from the launching of the Apollo II moon rocket from the Kennedy Space Center.

Beyond the urban and technical references of the imagery, and the numerically fewer but never relinquished images of art, we need to remember Rauschenberg's view of Leonardo's painting as without hierarchy. The data accumulated in the silk-screened paintings is not a program to be decoded iconographically by reference to a set of prior meanings. What we have, instead, is a scenic space which simulates, by the abundance of images and their connectivity, the relation to the world that we have in terms of moving about a city and using the mass media of communications. The iconography lies in the multiplicity, not in its reduction. Take one of his recurrent motifs: the tire.

63

57. Robert Rauschenberg. *Tadpole.* 1963. Combine-painting. 48 x 30¼.
Collection of Bruno Bischofberger, Zürich, Switzerland.

In *Monogram*, 1959, an angora goat is framed by an automobile tire; in *First Landing Jump*, 1961, a heavy tire stands on the floor in front of a painting. In the following year, in an environment at Amsterdam called *Dylaby* (from the words *Dynamic Laboratory*), he made a piece in which a wooden board, painted with a two-headed arrow, is jammed through a tire hanging on the wall. In *Tadpole*, 1963, there is a flat inner tube fixed above a silk-screened painting. *Map Room II*, a theater piece of 1965, includes a sequence in which a dancer inside a truck tire rolls across the stage. There is, I think, no single meaning common to each appearance of the tire; it is not a leitmotif. The meaning lies in the fact of sequence, in the accumulation of uses to which a tire can be put. It is an example of the interest Rauschenberg has in the recurrent and revived uses of objects as they change owners and uses, the changes in images that are combined in different sequences. As Rauschenberg has said: "the fact that the material is re-used is, in truth, the paradox. It ceases to be waste."[8]

Rauschenberg is a prolific artist who can tolerate a good deal of company as he works. This is because his improvisations, which are constantly inventive, are protected by operational custom. That is to say, his improvisation is concentrated on actions in which he is already proficient. For instance, when printing silk screens on canvases or transferring photographs onto lithographic stones, he is handling familiar material, using it in a serial form from one work to the next. Shrewd regulatory lore can be found, too, in the combine-paintings which seem so hectic in their intersection of different materials and sign levels. Bitite Vinklers has pointed out that "Rauschenberg continually made a fairly distinct separation between the flat collage materials he used and the three-dimensional objects; the relatively flat materials . . . are attached flatly to the canvas, referring to the surface, while the three-dimensional object, such as a stuffed bird, a chair, a pail, a pillow, is usually an appendage to the painting, either hanging or standing free from the picture plane."[9] Even in *Monogram*, where the goat and tire are mounted on a board, the board carries the usual amount of collage. This underlying simplicity enables Rauschenberg to improvise at speed, where a more sophisticated structure would impede him. Thus his plan depends on a tough simplification of formality to the point that it can absorb whatever he throws in or prints. The silk-screened paintings, it is relevant to note, are usually based on an underlying grid on which the islands of imagery are scattered.

The fecundity of the mass media makes it possible to find apposite material at random. For instance, on the day that I was listing Rauschenberg's use of tires, I came across an image in the *New York Times* of a tire underwater, the tread blurred by marine growth but discernible, with a fish drifting through the weeds sprouting from it: the photograph illustrated a story on the use of industrial waste to build an artificial reef. The recurrence of the tire in Rauschenberg's art has more to do with commonality (the multiple use of one object) than with fetishism or obsession. His tires do not function as symbols of something else but are exemplary of the adaptations and reuse which constitute the history of objects. Writing of his friend Oyvind Fahlstrom, Rauschenberg

defined the artist as "part of the density of an uncensored continuum that neither begins nor ends with any decision or action of his."[10] When an artist deals, as Rauschenberg does, in one brilliant tactic or another, with found material, this statement is literally true. The bits of materials existed before he found them, and the dimension of common experience from which they were annexed accompanies them. Thus the artist is not, as in idealist or expressionist theory, a unique source of ultimate knowledge, but, more modestly, one of the users of a flowing and continuous treasury of common objects and signs.

Discussing his reason for using a target and the American flag as subjects for a painting Johns characterized them in terms relevant to much of his iconography as "things the mind already knows. That gave me room to work on other levels."[11] This remark is one of the earliest statements of anti-invention opinion as it developed after abstract expressionism, but with the characteristically Johnsian reservation concerning "other levels." Apropos of another motif, Johns commented: "I'm certainly not putting the numbers to any use. Numbers are used all the time, and what's being done is making something to be looked at."[12] In most of Johns' work, the subject matter, or any appended objects, are thoroughly familiar, but their presence in the work of art is not, as in Rauschenberg, a declaration of common property, a touch of the statistical democracy of shared imagery.

Johns has conceded to the spectator the right to determine the meaning of his works, an example set by Marcel Duchamp. "The creative act is not performed by the artist alone; the spectator brings the work in contact with the external world by deciphering and interpreting its inner qualifications and thus adds his contribution to the creative act."[13] Johns' version of this position is as follows: "Publicly a work becomes not just intention, but the way it is used. If an artist makes something—or if you make chewing gum and everybody ends up using it as glue, whoever made it is given the responsibility of making glue, even if what he really intends is chewing gum."[14] "Meaning is determined by the use of the thing, the way an audience uses a painting once it is put in public."[15] The meaning I want to put on Johns' work, and which his apparent consignment of meaning to others permits, has to do with the interplay of "things the mind already knows" and problems of signification. (Incidentally, Rauschenberg's juxtaposition of images from divergent sources and his avoidance of a specific program for each work confers a comparable responsibility for interpretation on the viewer.)

In a review of the typographical English version of Marcel Duchamp's *Green Box*, Johns admired him for "wit and high common sense ('limit the number of readymades yearly'), the mind slapping at thoughtless values ('Use a Rembrandt as an ironing board'), his brilliantly inventive questioning of visual, mental, and verbal focus and order. . . ."[16] One praises what one would not mind being like oneself, and certainly the wit, the resistance to habit, the questioning, are in Johns' own work. *Three Flags* is, in some respects, a highly iconic sign, an accurate rendering of the design of the stars and stripes on a canvas of the same ratio as the flag. Its departure from the original has to do

66

Plate 5. Robert Rauschenberg. *Tracer.* 1964. Oil on canvas with silk screen. 84 x 60. Collection of Frank M. Titelman, Boca Raton, Florida.

Plate 6. Jasper Johns. *Studio No. 2.* 1966. Oil on canvas. 70 x 125. Collection of Mr. and Mrs. Victor W. Ganz, New York.

Plate 7. Joe Goode. *Happy Birthday.* 1962. Oil on canvas. 65½ x 65½. Collection of Janss Foundation, Thousand Oaks, California.

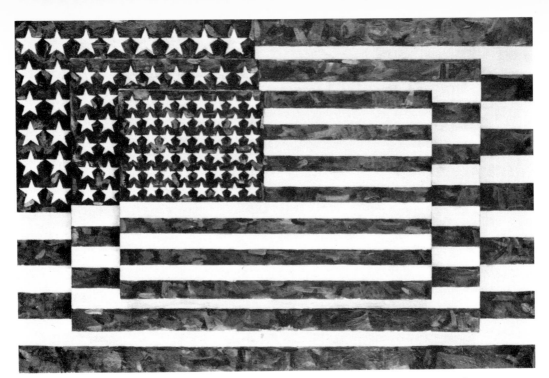

58. Jasper Johns. *Three Flags.* 1958. Encaustic on canvas. 30⅞ x 45¼ x 5. Collection of Mr. and Mrs. Burton Tremaine, Meriden, Connecticut.

59. Jasper Johns. *Grey Flag.* 1957. Encaustic and collage on canvas. 38 x 26. Collection of James Holderbaum, Smith College, Northampton, Massachusetts.

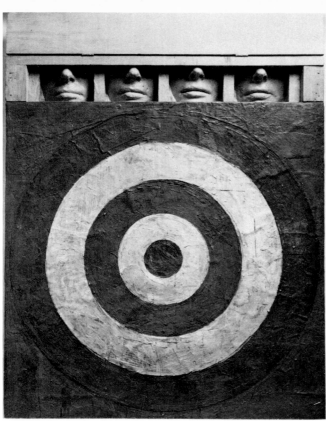

60. Jasper Johns. *Target with Four Faces.* 1955. Encaustic on newspaper on canvas, plaster, and wood. 26 x 26. Museum of Modern Art, New York; Gift of Mr. and Mrs. Robert C. Scull, 1958.

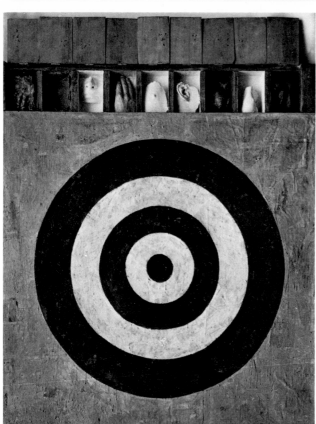

61. Jasper Johns. *Target with Plaster Casts.* 1955. Encaustic and collage on canvas with plaster casts. 51 x 44 x 3½. Collection of Mr. and Mrs. Leo Castelli, New York.

with its surface which is a restrained but animated paint skin, a sensual specific that coexists with the known emblem which is, in a sense, spaceless. In addition, three advancing but diminishing flags rise within one another, in steps—an unanticipated transformation of the flag. The physical charm of the surface is traditional to both the production and appreciation of painting. The starkly uninvented image, however, violates the expectation of connoisseurship, and, in this context, acquires a jolting problematic role. In 1958 I remember Johns saying: "Somebody said, 'It's not a flag, it's a painting.' But that's not what I meant. It's not a painting, it's a flag."[17] This exuberant reversal of aesthetic habit does not exhaust the flag paintings, but it is a reminder, at least, that the image is not simple, that it is the complexity of the simple that interests Johns.

In *Target with Four Faces*, the bulls-eye is centered, and the outer edge comes near to the edges of the square canvas at north, south, east, and west. Above it are four compartments containing identical fragments of plaster casts of a nose and mouth, which can be seen on an on-off basis according to the position of a hinged cover. The target is complete and single, the plaster casts are incomplete, regarded as anatomy, but their serial order overrides any sense of mutilation. The whole form of the target is, in a sense, echoed by the all-or-nothing cover (unlike the flaps in the *Target with Plaster Casts*, 1955, which are individually movable). One's actual sight of any symmetrical layout is usually approximate, somewhere off center at an arbitrary height, so the image is seen obliquely. When the symmetry is emphatic enough, however, the contingencies of seeing are dissolved by recognition of the known principle of organization. Similarly, the row of plaster casts supplements visual judgment by our recognition of serial order, with the result that the painting can be said to be situated somewhere between visual spectacle and ideas of order.

Signs, by means of which we refer to absent things and events, are present as the subject of Johns' art, but as an end, not only as a means or channel. It is at the root of his art's ambiguity. Johns' pleasure is to use signs in a context that can be resolved neither by recourse to the referent (something in the world) nor by purely visual enjoyment of the autonomous paint marks (something in the painting). There is a suspension of the expected reference and a consequent increase of other possibilities. It has been suggested, by Leo Steinberg, that the work's status as art intervenes to make the common sign (flags, numbers) useless, and, hence, aesthetic. Johns seems more concerned with a standoff between sign and object, however, than with a reconciliation of opposites in the context of art. In the early works, the frontal plane of the canvas is sometimes identified completely as the image, sometimes as a field of color carrying words, inscribed as on a stele. In the work of the 1950s, Johns seems to be presenting us with memorials of sign-systems rather than with operational signs; it is English, and other sign-systems, as a dead language. The flag is numbed into stillness, the target is unpierced.

The constituent bits of his art are familiar, but the work is enigmatic in sum. He is concerned with recognition as it shades into estrangement. In

69

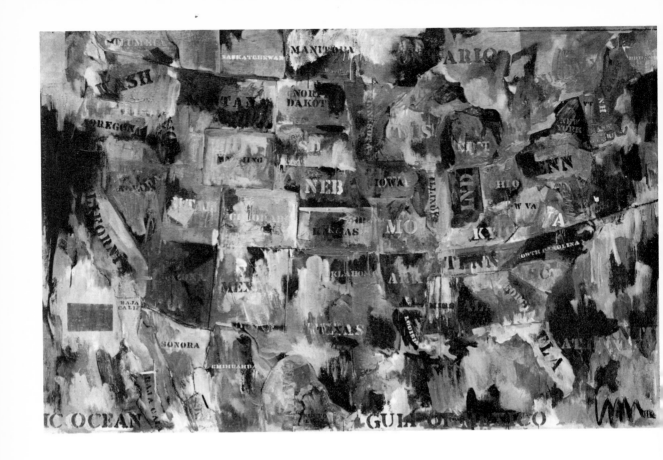

62. Jasper Johns. *Map*. 1962. Encaustic and collage on canvas. 60 x 93. Collection of Mr. and Mrs. Frederick Weisman, Los Angeles, California.

Johns' work, everything occurs for the second time. The words and objects are not only familiar on their first appearance, but are repeated from painting to painting or from painting to graphics, in an implacable survey of alternatives. The form of his earlier works outwardly symbolizes logic (neat painting, controlled emphasis, and nothing unruly occurring), but is this order? On the contrary, the neat form of presentation seems chosen to amplify the uncertainties involved. The deceptive order is the analogue of malicious knowledge, a term used to refer to knowledge about knowledge, signs used to discuss signs, and, by extension, art about art. The knowledge is, of course, malicious only with the spectator's consent, but given that, the speculation on syntactical nuance and double take becomes corrosive in its lowering of the reliability of signs.

Johns' purely artistic gifts are remarkable, clearly demonstrated in the precious, well-knit physiognomy of the early work. His relation to art is fond

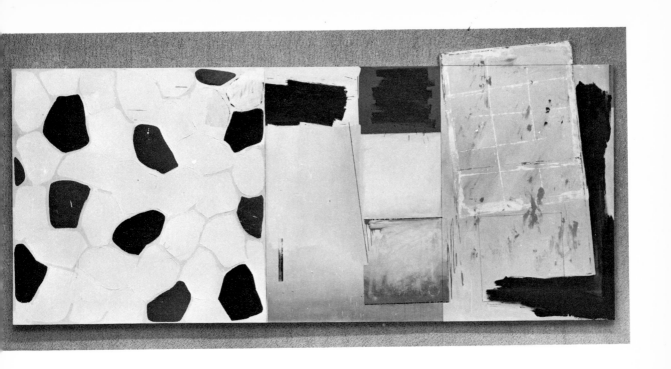

63. Jasper Johns. *Harlem Light.* 1967. Oil on canvas with collage. 78 x 172. Collection of David Whitney, New York.

and distrustful. He is acutely aware of the limits of any system of communication and does not exempt painting, which he does so well, from his sense of limits. The arbitrary and crumbling systems within which Johns has worked are handled with great poise and aplomb, giving precision to his entanglement of signs (and hence of the realities they are presumed to refer to). Of one of the number paintings, Max Kozloff has written: "the quietude of this kind of shallow, tabular imagery is impaired only by the staccato energy of the facture, confining itself restlessly to mimicking or transgressing the individual signs. Strokes poke in and around, over and under 'objects' which are wedged in or seem to dissolve into a nervous emulsion."[18] The paint and the image of the numbers are fused, as they were not in *Alley Oop*, but the puzzle is as malicious as it is graceful: are the numbers "objects"? They are painted somewhat as if they might be, and yet numbers, as such, have no plastic existence in space.

71

Johns had a considerable influence on abstract painters, as Nicolas Calas indicated in his aphorism: "Jasper Johns hit the target; Noland circled it."[19] Johns' paintings remained much smaller than those of Noland or Stella, who had learned both from his poker face and his symmetry, and it was not until 1961 that he began to work on a larger scale. It is typical of his independence that he seems to have taken pains to avoid the style in which Stella and Noland worked. What he did, in fact, was to elaborate another aspect of his work in which he had dissembled a kind of abstemious abstract expressionist brushwork. In the late 1950s, he produced a group of paintings in which the paint is primly ragged; it has a deliberated floridity. One effect of this was to take gestural brushwork, identified at the time with emotional candor, and drain it of passion, but, also, possibly, to save it from pretense. The irony of feigned expressionism issuing in a brittle constraint did not turn out to be one of Johns' best ideas, but he does not stop or start anything suddenly. What happened, as I read it, is that turbulent brushwork continued to interest him as a problem.

He made a small densely painted map of the United States in 1960 (Rauschenberg Collection) in which the piled-up paint turns the conventional form of the map into something like the jumble of sense impressions that a real landscape might provoke. In the following year, he painted the ten-foot-long colored *Map*, in which the boundaries of the states and partially obliterated stencils of their names constitute a hectic landscape space, made up of conventional boundaries rather than of objects. State limits are maintained, but the choppy rhythm of their placing in red, yellow, and blue planes, burrowed into or crossed by qualifying colors, is visually rich and conceptually continues his taste for complex signs. The cartographic forms dilate into atmospheric and spatial mobility. There are two variations on the map, both about eight feet long, one gray, 1962, and one which is more abruptly phased and more painterly of 1963. *Fool's House*, 1962, shows clearly his move from the delicate to the heavy-handed, from the restrained to the emphatic. The work is what Rauschenberg would have called a combine-painting and includes a broom suspended in the painting, smeared with paint, so that it becomes an image of the artist's brush, though a crude one.

The maps prepare for the remarkable series of large paintings in horizontal format which are one of the major achievements of American art of the 1960s: *Diver* 1962 (14 feet long), *According to What*, 1964 (nearly 17 feet), *Studio I*, 1964, *Studio II*, 1966, and *Harlem Light*, 1967. In *Diver* there is a tumultuous spread of paint, genuinely messy compared to his earlier control, and a color chart of gray tints that resembles a flight of steps. It is done on five panels, abutting horizontally, with dollops of paint, bare patches of canvas, an inverted chair attached to the top of the painting with the negative cast of a leg sitting in it, and two substitutes for the gray chart of *Diver*. These are a series of color circles and a continuously graded tonal spectrum. It is as if these two columns, pretty central in location, indicate hue and value, while the rest of the painting demonstrates various degrees of their combination. (The use of primary color in big squares seems to refer to Hans Hofmann's later work.) *Studio I* returns the stormy panorama to the studio, with a door at the

64. Comic Book, ca. 1961, detail. The source of Roy Lichtenstein's *Blam*.

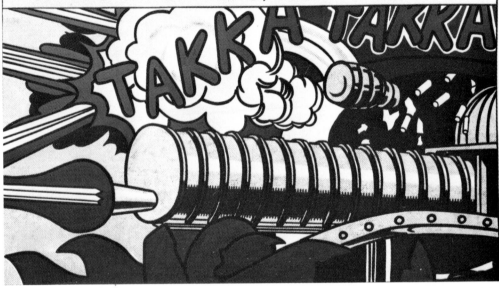

THE EXHAUSTED SOLDIERS, SLEEP-LESS FOR FIVE AND SIX DAYS AT A TIME, ALWAYS HUNGRY FOR DECENT CHOW, SUFFERING FROM THE TROPICAL FUNGUS INFECTIONS, KEPT FIGHTING!

65. Roy Lichtenstein. *Takka Takka*. 1962. Oil on canvas. 56 x 68. Collection of Peter Ludwig, Wallraf-Richartz Museum, Cologne, West Germany.

ON GUADALCANAL, THE EXHAUSTED MAR-INES, SLEEPLESS FOR FIVE AND SIX DAYS AT A TIME, ALWAYS HUNGRY FOR DECENT CHOW, SUFFERING FROM THE TROPICAL FUNGUS INFECTIONS, KEPT ON FIGHTING!

66. Comic Book, ca. 1961, detail. Source of Roy Lichtenstein's *Takka Takka*.

angle of a stacked canvas jutting outside the rectangle and with color imprints along the wall. *Studio II*, of two years later, reinforces the work-place image of the painting. *Edingsville* combines pure color and atmospheric brushwork, a cluster of objects, and the imprint of a leg. The paintings are images of the studio and activity in the studio, but whereas the early work dealt in ambiguous distillations, the new work depends on profuse rather than on economical imagery. The distance from one end of the painting to the other, the unlikeness of one part to another, are what interests Johns in these late works; he has formulated a discursive method and brought it to an art previously concentrated and aphoristic. His core of wit is retained, as in, for example, the note he made of a "Flagstone ptg. 2 panels, one in oil, one in encaustic."[20] The patio section of *Harlem Light* depicts flagstones, a verbal echo of his early visual image, of course. "To see that something has happened. Is this best shown by 'pointing to' it or by 'hiding' it."[21] In his earlier work, it was done by concealment and in the new work by pointing. Behind the syntax of expressionism, Johns has expanded his scale formidably, while still speculating on the nature of signs. He does it now with gross daring.

Roy Lichtenstein

Roy Lichtenstein sets up a situation in which style is subject matter and governed by the same rules of discourse as iconography. The subject matter of *Blam* at one level is war, but Lichtenstein has not invented his subject; he has taken it from an existing image in a comic book. The original has been considerably revised to arrive at Lichtenstein's composition in which both plane and explosion radiate from a common center in the picture. However, through these changes he has not abandoned the recognizable style of the original, though with an important qualification. The outlines, the solid colors, and the simplifications of surface refer less to the particular drawing from which *Blam* is taken than to the comics generically. The source of *Blam* has a naturalistic open space, and the objects in it can be seen together in an instant of time, though all are diverging. Lichtenstein, on the contrary, has arrested the action, not only by dispensing with narrative and with other panels, but by elaborate formalization, such as the play of ovals on the right set up by the jet intake, the cockpit, and the ejected cockpit cover. The linear pattern that he builds up does not de-comicize the image, however, because it resembles the comics as a style. Lichtenstein's references are on two levels: to a specific drawing, which only he knew at the time of working, and to a general knowledge of comics style, a cliché that we all share. The construction of the picture took place in the former area but was perceived by the early audience wholly in the latter.

A knowledge of Lichtenstein's sources[1] reveals that the act of switching an image from one channel (printing) into another (painting) is fairly complex. It involves Lichtenstein's view of style no less than his view of the mechanics of

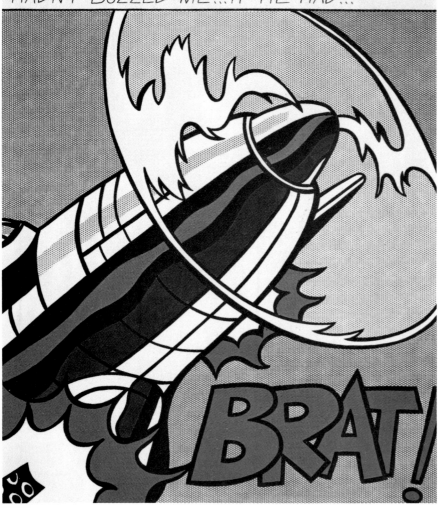
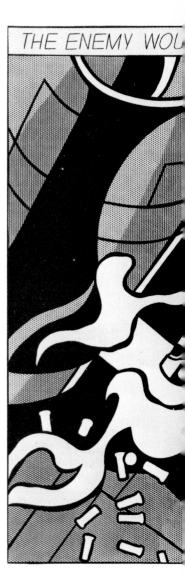

67. Roy Lichtenstein. *As I Opened Fire. . . .* 1963. Magna on canvas. 68 x 168. Collection of Stedelijk Museum, Amsterdam, The Netherlands.

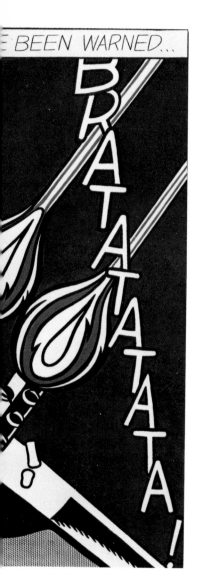
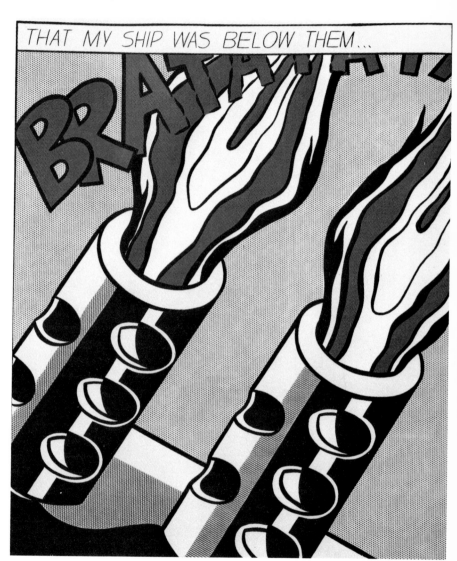

composition. In the *Modern Paintings* he devised new configurations, less from quotations than by staying within the parameters of Art Deco. A style or a period look can be represented by a selection of representative features, and this is what Lichtenstein has done, for both comics and Art Deco. Style, defined as the constant form of an artist or a group, can, at one end of the spectrum, be studied to indicate unique matters of personality, but it can also be quantified as an ordering device, as in sampling. This is a part of Lichtenstein's central interest in the cliché, which has the virtue of being common property and highly legible. Alain Robbe-Grillet, taking an interview with Lichtenstein that he read as his starting point, paraphrased the artist as saying: "I have the feeling that these flat images conform far more to what really goes on inside our heads, than those false depths"[2] of lyrical abstraction or abstract expressionism. The clichés of conceptualization, like the clichés of style, provide the artist with clear form. The notion of cliché as subject matter is not so radical; it was pursued by nineteenth-century genre painters, and among those whose approval they earned was van Gogh. By using unknown collaborators, to whom he leaves the task of invention—regarded in art theory since the sixteenth century as the real test of an artist—Lichtenstein is free to do one of two things. He can either switch a comic strip into a fine art context or switch a work of art that belongs in one system of values to another set, as in his *Rouen Cathedrals (Seen at Three Different Times of Day)* after Monet. We expect iconography to enlighten us as to a picture's meaning, but at just this point, Lichtenstein poses a problem of conversion. The annexing of existing sign-systems by art brings a malicious ambiguity to bear on the ideas of expression and depth. Cliché takes the position of meaning.

In the early polytych *Live Ammo*, 1962, Lichtenstein touched on the possibilities of disjunct imagery, in an array of land, sea, and air warfare. His formal imagination, however, is more at ease with tighter relationships, such as the triptych of 1964, *As I Opened Fire*. Here are three successive views of a plane: the first of the nose, then a closer view of the guns in the wings, and finally the barrels of the guns in huge close-up. The flaming gun nozzles are presented in each picture, getting larger and moving from lower left to upper right in sequence. The onomatopoeic words *Brat or Bratatatata* of the guns follow this movement, but in the center panel, the yellow letters of the work trail downward like the shower of ejected cartridge cases. Despite the cinematic flow of the images the sky varies: there is a purplish screen of dots on the left and a blue screen on the right, with a strong solid blue at center to give stability to the left-right sequence.

Lichtenstein's use of style as subject matter is an essential part of his personal work as well as characteristic of Pop art, by and large, as an art of quotations, translations, imitations, and double-takes. A possible analogy would be to nineteenth-century historicism, when the traditional custom of respectful quotation from the classics expanded to embrace all periods and countries as sources. There is a comparable abundance in the assimilation of a wide range of sign-systems in Pop art and the devising of original connections between the disjunct materials.

78

68. Package designs. Source of Roy Lichtenstein's *The Refrigerator.*

69. Roy Lichtenstein. *The Refrigerator.* 1962. Oil on canvas. 68 x 56. Collection of Mr. and Mrs. Peter Brant, Greenwich, Connecticut.

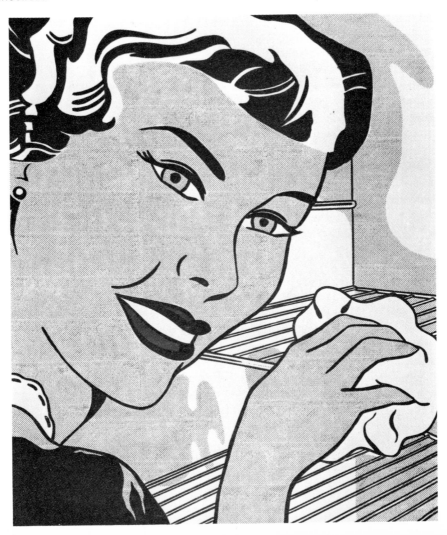

Lichtenstein's *The Refrigerator*, 1962, is derived from a domestic package. He has dropped the verbal matter and retained the image of the housewife, which he condenses from a naturalistic spatial sprawl into a tight form. This is a less effectual image of action, but what he is after are linear analogues of hand and cloth, face and hair, and the legibility of commercial style compensates for the decorative arabesque. It is a good example of an original art work pretending to be a copy. The communications industry has grown at an extraordinary rate since the 1920s, and the influence of its visual and verbal material is as clear on Pop painting as it is in the writings, though not in the art, of earlier artists. The heroic content remains, in a sense, in the war comics, but mass-produced domestic objects, reformed by technology, are a legitimate extension of the original proindustrial art movements of, say, Gris' and Léger's paintings of siphons.

Diane Waldman has written that the term *Pop art* has caused a neglect of "the tradition of realism in American art"[3] as it persists in the new work. However, Lichtenstein is not a realist: the fact that many of the objects he depicts are common or that his sources are popular does not amount to a definition of realist painting. He is not discovering unsuspected wonders or conferring dignity on the overlooked: on the contrary, his subjects are known beforehand to the spectator and depend on being recognized as existing signs. The original source which was a signifier becomes the signified in the painting, and the original referent, though clearly present, is transformed by indirection. Nicolas Calas has referred to "the paradoxical effect of making methodology the subject matter of art, an idea most eloquently demonstrated in Lichtenstein's use of the brushstroke as the content of a new image."[4] The process of painting as an image in a painting and switches of significative functions are not a matter of realism, not even of *trompe-l'oeil*.

Lichtenstein believes in composition as the balance of contrasting but compatible forms, in which size, direction, and color can be related; in which warm colors compensate for cool, in which curves ameliorate right angles, and in which details enliven large spaces. His work until the mid-1960s is constructed on these principles, and his accommodation of far-out image-source with academic picture-building is an engaging aspect of Pop art's play with ambiguous sign-systems. It is not, as formalist critics presumed, a sign of weakness but one of doubt operating equally corrosively in two directions.

Lichtenstein, up to this point, is basically a draftsman who uses color to fill in and jazz up linear armatures. His recorded liking for Picasso and Miró as caricaturists,[5] which I think is accurate, accords perfectly with this view of him. He had a brusque, serviceable way of working which gave him the freedom to construct logical compositions, but which did not exclude the possibility of indifference to and self-cancellation of the iconography. In 1964, he began his landscapes in which the linear structure indispensable to the comics was gradually dismantled. It is not that Lichtenstein abandoned references to extra-artistic objects, but that he changed his subject to one that would permit him to shift the basis of his art without giving up the dimension of sceptical allusion. Obviously landscape provided the license, and he could use color, with-

80

70. Roy Lichtenstein. *Woman with a Flowered Hat.* 1963. Magna on canvas. 50 x 40. Private collection.

WE
ROSE UP
SLOWLY
...AS IF
WE DIDN'T
BELONG
TO THE
OUTSIDE
WORLD
ANY
LONGER
...LIKE
SWIMMERS
IN A
SHADOWY
DREAM...
WHO
DIDN'T
NEED TO
BREATHE...

71. Roy Lichtenstein. *We Rose Up Slowly.* . . . 1964. Oil and magna on canvas. 68 x 92. Collection of Karl Ströher, Hessischen Landesmuseum, Darmstadt, West Germany.

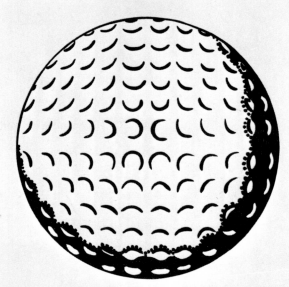

72. Roy Lichtenstein. *Golf Ball.* 1962. Oil on canvas. 32 x 34. Collection of Mr. and Mrs. Melvin Hirsh, Beverly Hills, California.

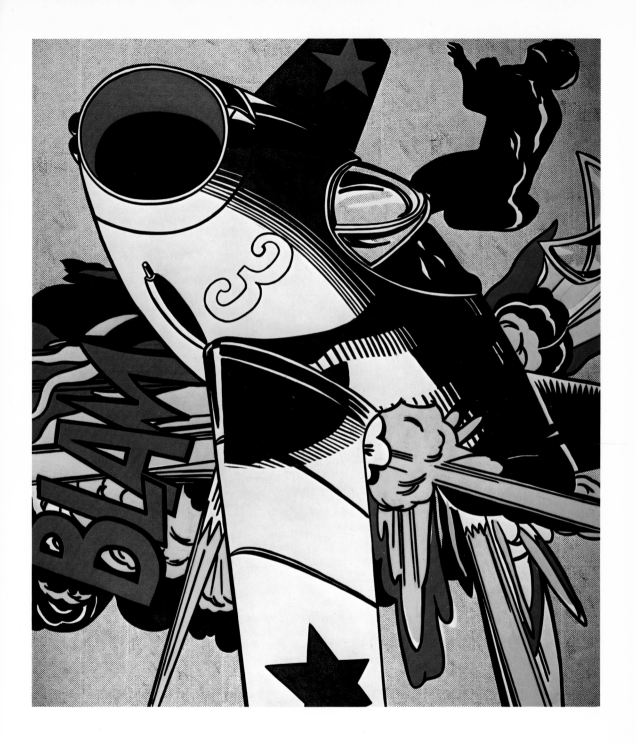

Plate 8. Roy Lichtenstein. *Blam*. 1962. Oil on canvas. 68 x 80. Collection of Richard Brown Baker, New York.

Plate 9. Claes Oldenburg. *Auto Tire and Price (Auto Tire with Fragment of Price).* 1961. Muslin soaked in plaster over wire, painted with enamel. 49 x 48 x 7. Collection of Pat Oldenburg, New York.

Plate 10. Andy Warhol. *Lavender Disaster.* 1964. Silk screen on canvas. 108 x 82. Collection of Mr. and Mrs. Peter Brant, Greenwich, Connecticut.

73. Roy Lichtenstein. *Mirror (In Six Panels).* 1971. Oil and magna on canvas. 120 x 132. Collection of the artist.

out black, to create the image. He enlarged the dots in his screens and over-lapped one screen with another to make generalized evocations of horizontal space in terms of surface and color, not boundary, as in *Untitled*, 1965. This period, with its very uneven level of work, looks like a time of strain, a struggle to retain the public resonance of clichés, while giving up the linear forms in which visual commonplaces are usually summarized. However, the break represented by the landscapes was decisive, for without turning into an abstract painter, he did move to a nonlinear mode of painting.

The *Modern Paintings*, begun in 1966, despite their iconographical expansion, are a prolongation of his set form, a linear structure with color added. The wit of the early pieces in the series is lost as work progresses; the paintings themselves become heavy and ornate and not just double-takes on heavy ornament. On the contrary, the landscapes, or rather the formal possibilities latent in them, seem to have engaged Lichtenstein more significantly, and this leads to the Monet paraphrases begun in 1968 on the basis of his knowledge of the preparations for John Coplans' "Serial Imagery" exhibition in the summer of 1968. In the prints and paintings derived from Monet's haystack and Rouen Cathedral series he is coping with the problem of color in relation to preexisting systems. The multiple coruscation of Monet's colors are reduced to a combination of regularly perforated screens, with dilated dots, applied in overlays of one color at a time. In these works he is dealing seriously with color in the absence of line and really extending his wit into a new area. Lichtenstein told John Coplans that "there is something humorous about doing a sunset in a solidified way, especially the rays, because a sunset has little or no specific form."[6] And there is something "humorous" in switching Monet's paintings to a flat, hard, systematic graphic technique of production. What is sensuous and momentary in Monet becomes quantified as color separations. The dots fall in the zigzagging interstices of the facade. The dots are large, as firm and clear as drops of mercury, though where the superimposed screens overlap they generate splintered star forms. I don't want to present too much justification for it, but Lichtenstein's *hardening* of Monet has an historical precedent. Monet's haystacks influenced Mondrian to do a haystack series of his own and subsequently Mondrian developed a plus-and-minus drawing code derived from a church facade. This form of notation by systematic small points is in the background of Lichtenstein's own use of points or dots. In a way, the pictures are like a neo-impressionist revision of Monet, done not by Seurat but by Signac with his large, blunt pointillism. This sequence is not in the least esoteric, as both Mondrian's plus-and-minus period and Monet's series are very familiar elements in recent art talk, so that the presence of cliché should not be overlooked in these paintings.

The mirrors, like the Monet paraphrases, stress screens of dots rather than outline drawing, but in terms of gradation rather than overlapping, and tonally rather than coloristically. Mirrors are an evocative theme in art, connected in earlier art with vanity and in the nineteenth century with a Narcissus-like self-regard. However, Lichtenstein's deadpan handling effaces all this. In his mirrors we can neither straighten neckties nor comb hair: it is what happens

84

74. Roy Lichtenstein. *Untitled.* 1965. Oil and magna on canvas. 48 x 68. Collection of Victor Langen.

75. Roy Lichtenstein. *Still Life with Crystal Bowl, Lemon, Grapes.* 1973. Oil and magna on canvas. 40½ x 54¾. Collection of the artist.

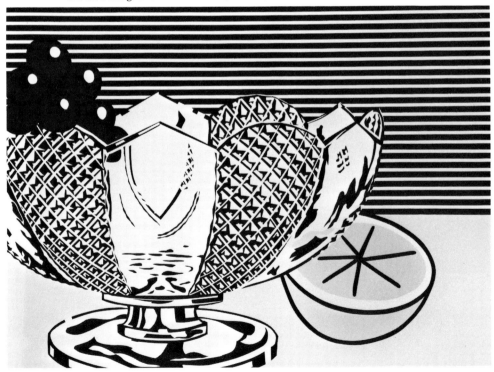

when Dracula looks into a mirror—vampires have no reflections. The responsive reflections that can be simulated by metallic paint are not used by Lichtenstein, whose austere encoding denies such traces. The doubt, the cancellation of clichés, reaches a climax in these works. These studies of highlights are physically unconvincing but conceptually exact, in that a known convention for reflections is being employed, as much for its artificiality as for its likeness to a visual phenomenon. The unpaintable subject of mirrors leads to the series of drawings and paintings called *Entablatures*, in which architectural decorations are presented in the same size as the original moldings, though flat and in diagrammatic chiaroscuro. Egg and dart, Greek key, and other motifs mass-produced in the nineteenth century for the ornamentation of family houses, not as they originated in the classical past, are Lichtenstein's theme. It is another discredited area. Although he has returned to drawing in this series, it is without the fullness of incident that marked his early linearism. Instead of an art based on boundaries, Lichtenstein has moved to an art predicated on surface and allover or continuous animation. The chronological thrust of his art, as a whole, is from crowded to spare, from tangled to empty.

James Rosenquist

Rosenquist's stories, oblique, rambling, and vivid, give a sense of his take on America. "He was black with dust, but there were white circles around his eyes outlining the goggles he wore while plowing."[1] "In Six Flags Over Texas, an amusement park near Fort Worth, I got into the simulated Louisiana Riverboat. A young man in costume began to pole the boat through an s-shaped ditch filled with water. The boat started with a jerk, actually being propelled by huge teeth coming out of the water."[2] Here are two versions of one of his stories: "I was working on top of the Latin Quarter roof in Times Square, painting a 'Join the Navy' sign. Above me five more stories in the ironwork were electricians repairing light bulbs in the Canadian Club sign. As a practical joke they dropped four boxes of light bulbs down on me. For about thirty seconds I was showered with breaking light bulbs." And again: "One time I was working up there and there was a girl in the backyard of a building sunbathing in the nude and I was leaning off the edge of this thing looking at her and two workmen dumped about 200 light bulbs down on my head from about five stories and I thought it was bullets—they popped off and went down my neck and everything else."[3] There is a tangy flavor of American life to these stories which is very much present in his painting, a folk-realism of encounters and surprises. "On the road, a trailer truck roared by and an airplane flew overhead."[4] Compare this truck with those referred to by Robert Rauschenberg in his notes on "random order": with sound scale and insistency trucks mobilize words and broadside our culture by a combination of law and local motivation that cannot be described as accidental."[5] The urban diversity of Rauschenberg's verbal image, the equivalent of his silk-screened

76. James Rosenquist. *F-111*. 1965. Detail. Oil on canvas with aluminum. 120 x 1032. Collection of Mr. and Mrs. Robert C. Scull, New York.

77. James Rosenquist. *1947, 1948, 1950*. 1960. Oil on masonite. 30 x 87⅜. Collection of the artist.

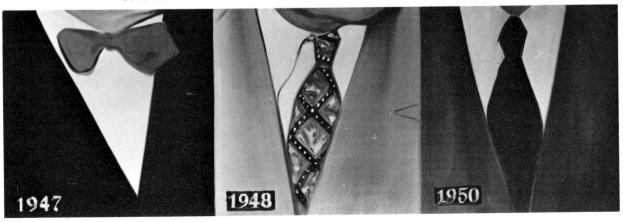

paintings, is such that we do not expect any single image to be accounted for by terms that refer to all the other images. Rosenquist's clusters of discontinuous objects are not discrete and scattered in this way; he has not relinquished causal relationships, even though their sequence may not always be clear.

Rosenquist's America is more like Robert Indiana's, an example of which is in Indiana's linking in *Year of Meteors*, 1961, of nineteenth- and twentieth-century Americana. Rosenquist does not evoke the nineteenth century, but he does have a sense of America as a large but united place, in which all kinds of bonds exist between people and objects. The crowded present, not the historic past, is his area of reference. Referring to *I Love You with My Ford*, Rosenquist defined his notion of time as a devalued zone between now and the past. "In 1960 and '61 I painted the front of a 1950 Ford. I felt it was an anonymous image" from "a time we haven't started to ferret out as history yet."[6] *Four 1949 Guys* is another example of this feeling for neutral style and for a period which is post-historical but not fully the present. In the early 60s, even his colors were recurrently red, white, and blue, not only in Uncle Sam's hat as flower pot or cornucopia in the World's Fair mural, 1964, but in a group of billboard- or CinemaScope- format paintings, such as *President Elect*, *A Lot to Like*, *Silver Skies*, *Nomad*, *Lanai*, and *Taxi*.

F-111, 1965, is the painting in which Rosenquist's sense of America as a continental presence and as technology are most clearly stated. In program, the painting is not unlike a WPA mural, just as *Horse Blinders* is not unlike a Wonders of the Technological Age mural or a foldout in an encyclopedia. Once this is said, of course, it is seen not to be accurate enough; it does not take into account the brilliant personal control of the former or the personal obscurity of the latter. Rosenquist thinks in terms of objects and conjunctions of objects with symbolic meanings unlike, say, Roy Lichtenstein who minimizes levels of reference. Marcia Tucker has suggested the process of perception is his real subject.[7] If this is so, it does not get rid of the problem of signification, because Rosenquist cannot, nor can any artist, depict on a delimited plane the process of perception that occurs in an infinite field. If an artist paints perceptual processes it becomes a diagram of perception and, as one particular diagram is isolated from among others, it is subject to the iconographical interpretation we already bring to bear on objects and their locations in space. Rosenquist has an allegorical imagination which takes as its subject the man-made landscape and our positions within it. In the seventeenth century, Dutch still-life artists could assign symbolic meanings, vanity, or appetite, to realistic objects without compromising the concreteness of the things shown, but this cannot be done without a shared set of symbols. The sign-systems that we do have in common are provided by advertising and the mass media, and Rosenquist uses these, but liberated from thematic constraint.

At one point, the fuselage of the *F-111*, which runs through the whole painting, is interrupted by a smiling child under a hair drier. According to the artist, "the little girl is *the* female form in the picture. It is like someone having her hair dried on the lawn, in Texas or Long Island."[8] Both the plane and the girl are elements that can be reconciled within Rosenquist's epic view of things

American. Or the child can be read as a contrast to what is literally the war machine; she is happy now, but what will the future bring? In addition, the hair drier with its lustrous highlights and (pre-Richard Estes) reflections is no less a product of technology than the plane. The drier can certainly be construed as an analog of a high-altitude flying helmet, thus casting the child as if she were a member of the air crew. Rosenquist referred to the dependence of people "in Texas or Long Island" for work on the production of the plane, and crossovers like that of the helmet and hair drier carry this further. The picture is, in a sense, a visualization of systems theory, with the support system of the plane rooted deeply in American society. Another connection is given by the artist who, after referring to the A-bomb mushroom in one section, said: "then next, that's an underwater swimmer wearing a helmet with an air bubble above his head, an exhaust air bubble that's related to the breath of the atomic bomb. His 'gulp' of breath is like the 'gulp' of the explosion. It's an unnatural force, man-made."[9] (There is also the pair of fire and water.) In addition, I am reminded of Bruce Conner's *A Movie*, 1958, in which shots of the mushroom cloud precede a sequence underwater in which a diver sinks into the hold of a wreck with a rhythm that implies the extinction of the human race.

F-111 combines the image of America as the *Big Country* with a highly developed war technology. *Horse Blinders*, 1968–69, Rosenquist's next big picture, shifts the view to a control center, like the driver's seat, the cockpit, though the governing theme is kitchen technology. There is an enormous finger, reminding one of all those ads for touch control, a telephone cable— its color-coded wires opening out like a bouquet, and motion studies of a spoon beating food in a bowl, and a snaky telephone flex. A block of butter melts in a pan over a glowing burner, and there are images of energy in wave form. Apropos the man–energy theme, Nicolas and Elena Calas point out that "the giant finger points to an acoustic device emitting sound. The room is in fact filled with noise, with 'rumor,' according to the artist, coming from without."[10]

The title, *Horse Blinders*, referring to the item worn by horses to block peripheral vision, is unclear. Presumably the artist is either (1) freeing us of our blinders so that we can see the world more widely or (2) implying that the objects in the painting act like horse blinders on us, their users. These drastic alternatives are not resolved in the painting, and it is not part of Rosenquist's intention to do so. Forms are defined as obscure bosses of expanding detail or as amorphous surfaces that expand into what Rosenquist once called "immediate infinity." The effect is of objects slipping out of focus, losing their boundaries. Enlargement and identity loss go together: The result of Rosenquist's giantism is doubt, not clarity. In addition, the artist uses multiple viewpoints for the different objects and areas of the painting. There is no correlation between the scene depicted and an ideal point of view from which the spectator can occupy the equivalent of the artist's original viewpoint. There is, in fact, a dissolution of vantage point so that the spectator is put into a kind of nowhere by the scale of the array. In total, these environmental paintings propose an epic treatment of American subjects, and, at the same time, there

78. James Rosenquist. *Woman, I.* 1962. Oil on canvas. 72½ x 84. Collection of Mr. and Mrs. Charles F. Buck, Walker, Kansas.

79. James Rosenquist. *Woman No. 2.* 1962. Oil on canvas. 70 x 70. Collection of Mr. and Mrs. Morton G. Neumann, Chicago, Illinois.

is a postponed closure of the relationships and a derealization of the objects themselves.

By derealization I mean the obverse of making real something that was imagined—something that Rosenquist could not do in painting if he did not have common ground with his spectator in the form of preknown objects and recognizable types of signs supplied by the mass media. By using known sources, Rosenquist is able to make us aware of the degree of abstraction or transformation that they are undergoing. Hence, his ability to give us a familiar world and to withdraw it from us. He depicts the world in terms of those episodes in which we lose our grip on it. His use of the mass media as a legible sign inventory existing prior to the painting is obviously held in common with other Pop artists. On the other hand, no other Pop artist used this fund of imagery and technique the way Rosenquist has, celebrating America and alienation from it. His is a unique moralism, articulate but secretive.

Between 1952 and 1960, Rosenquist painted outdoor commercial jobs, starting with "storage bins, grain elevators, and gasoline tanks throughout Iowa, Wisconsin, and North Dakota," to quote Linda Cathcart's chronology (Tucker's catalog). From 1957, he painted billboards in New York City, and at the same time, evolved his own painting to a free brushy style represented by such paintings as *Astor* and *Mayfair*, both of 1958. *Zone*, 1960, is said to be his "first painting which employs commercial techniques" (Cathcart again), though according to Lucy Lippard, much repainted in its present form.[11] However, the dating of his works suggests a less abrupt change to the real thing in Rosenquist's art. In 1959, for instance, he painted *Four 1949 Guys*, which is characteristic of his mature work inasmuch as the four sections (containing a clearly rendered ice-cream cone and incomplete images of men) indicate recognizable poses, but the identity of the actors is blocked. This mix of concreteness and evasiveness is fully characteristic of his art. It is one of a group of paintings done between 1959 and 1961, which are solemn in color, darkly shadowed, and somewhat labored in paint-handling.[12] It is as if Rosenquist were working for a closed, dense, paint deposit in opposition to the open and fluid surface of billboard painting which, though legible at a distance, is porous close up. At an opposite extreme is *President Elect*, 1960–61, which is the closest of all his paintings to a regular billboard, in its open touch and public face. It is a clear, trite, American triptych: hero's head, hands demonstrating a cake's texture, and part of an auto. In successive paintings, Rosenquist abandoned the heavy surface and concentrated on reconciling the formal properties of the billboard and easel painting. *The Lines Were Etched Deeply on the Map of Her Face*, 1961, reveals the successful intersection of personally generated images and a technique derived from commercial art. The collision of the objects is sharper than later on, but a principle of intercepted images and suspended explication has been established.

Tube, 1961, is an extraordinary painting, a tondo painted as if it were a rearview mirror or a comparable reflecting surface. A section of an automobile appears at the center of the image, which otherwise consists of unidentifiable reflections (an anticipation of Lichtenstein's mirror paintings of

80. James Rosenquist. *Tube.* 1961. Oil on canvas. 58″ diameter.

81. James Rosenquist. *The Lines Were Deeply Etched on the Map of Her Face.* 1962. Oil on canvas. 66¼ x 78¼. Collection of Mr. and Mrs. Robert C. Scull, New York.

1970). Rosenquist has brought into painting, from his billboard expertise, a range of hitherto unpainted textures, such as curved reflective surfaces, expanses of crumpled metal, and amorphous fields of flesh or drapery. It is not an image of the process of perception, but it does create a situation in which we are reminded of perceptual crises and double-takes in our own lives. *Tube* is not explainable as the reconstruction of an objective single event, as it is not iconic in correspondence to a possible situation. However, both the inserted image of the car and the reflections are compatible stylistically, as parts of an easy-ranging eloquence of flowing brushwork. Rosenquist has taken the strangely immersive experience of painting enormous forms close up and found a way to transfer them to moderate-sized canvases. Who painted reflections five feet across before Rosenquist? To quote Marcia Tucker, Rosenquist switches "the accepted values of objects and field,"[13] so that sky can become a solid patch, and an object seen near at hand can dilate to field status. Thus the derealization of Rosenquist's objects, recognized but doubted in their substantiality or wholeness, is the result of a coincidence of the formal resources of commercial art and the demands of an authentic personal imagination.

Lucy Lippard suggested of *Capillary Action 1*, 1962, that the "photographic grays and 'natural' tones are played against each other to expose the artificiality and banality of nature. A *grisaille* foreground implies 'Please Don't Step on the Grass,' a Kelly-green panel stuck over a swatch of paint-smeared newspaper and tape implies 'Wet Paint.' Rosenquist says it is about 'seeing abstraction everywhere, looking at a landscape and seeing abstraction.' "[14] Tucker, discussing the same picture, notes: "color reverses the illusion of distance . . . because the foreground is gray and the background green; this is the opposite of the way grayed-out color is traditionally used to indicate distance and brightened tones are used to suggest nearness."[15] Lippard's nature and art polarity and Tucker's foreground and background exchange both suggest the complexity of Rosenquist's pictures, which are frequently hard to read. The fact is that in all of his work, any objects that he depicts are mediated by intervening image-systems. That is to say, in addition to the channel characteristics of painting itself, there are references (no less real than to the objects cited) to preknown styles of communication. The intervening system is a part of the spectrum of mass communications, combining billboard techniques of high-impact rendering with wider references to advertising style in general. Aside from the convincing internal evidence, photographs of the artist's studio show an abundance of pages of magazines and newspapers pinned to the walls.[16] Rosenquist introduced a statement of his by saying: "In the recent past I have had these experiences that I have thought of in terms of media."[17] The experiences were episodes of the kind quoted above, half folklore, half personal epiphany. To quote from an interview: "I still think about a space that's put on me by radio commercials and television commercials because I'm a child of the age."[18]

America cut the wilderness into states by arbitrary divisions imposed on the land, with only coincidental union with natural boundaries. Rosenquist's

82. James Rosenquist. *Silo*. 1963–64. Oil on canvas. 114 x 140 x 24. Collection of Tate Gallery.

83. James Rosenquist. *Director*. 1964. Oil on canvas. 90 x 62. Collection of Mr. and Mrs. Robert B. Mayer, Winnetka, Illinois.

84. James Rosenquist. *Untitled, Joan Crawford Says.* 1964. Oil on canvas. 92 x 78. Collection of Galerie Ricke, Cologne, West Germany.

85. James Rosenquist. *Time Flowers.* 1973. Oil and silk screen on canvas. 68 x 83½. Collection of Max Palevsky, Los Angeles, California.

compartmented imagery is similarly arbitrary, often violating preexisting contours. The sectionalized imagery runs deep, taking the forms of painted division where the eye goes from, say, a band of profile to a stratum of spaghetti, or of multiple canvases, in which the eye scans not just depicted breaks but real internal changes of level, as in *Capillary Action 1* with its projecting panels. The title *One, Two, Three-Outside* (sometimes given erroneously as *One, Two, Three, Out*, an implicit pun but not the prime meaning) refers to a painting which consists of the fragment of one image, and a second and a third part, which is a projection of the sides of the picture, linked by a wire, the "outside" of the title. Sectionalization reached a climax in *F-111* with its fifty-one parts which Rosenquist originally intended should be sold separately. It seems that Rosenquist opposes the easy unities of large-scale, outdoor, commercial painting, a play of divisive and autonomous parts, whose concreteness grinds against simplification. It is by this arbitrary sectionalizing that Rosenquist achieves a special point. Selection and enlargement of detail are hardly new in painting, but Rosenquist avoids typical cues and presents objects in terms of unanticipated detail or indeterminate surface. The recognition of wholes is delayed by the cropping of imagery, not with the purpose of inducing surprise so much as to postpone closure. He is a master of the transitions between painted and three-dimensional sections, with a gamut from jump to glide.

The technique given in *The Lines Were Deeply Etched on the Map of Her Face* is taken to a high point of eloquence in *Lanai*, 1964, in which the protection of anonymous time is dismissed. In the early 60s, Lichtenstein and Dine both used anonymous material as their sources: in Lichtenstein's case it was long-used and unrevised graphic commercial art and in Dine's case it was tools and fittings that were common and efficient enough to be, in a quotidian way, timeless. Johns' ignoring of the expansion of the number of the states in his flag paintings is another example of prudent commonness preferred to risky topicality. Rosenquist's interest in temporal anonymity is analogous to this—a safeguard against being swamped by the "visual inflation," as Rosenquist called it, of the developed mass media. By 1964, however, he was confident of his ability to use contemporary imagery without the shield of presumptive permanence. In *Lanai* the car is a new one, sleek, with a boxy look, and the peaches are as glorious as color reproductive processes can make them. The kneeling nude is, of course, a reference to the White Rock maiden, and it should be noted that she is in her new pose, with knees together. She kneels, however, in a new context, on the edge of a swimming pool. The tubular railing rises inward from lower right, as a spoon scoops up a peach from upper left. The transitions between sections, both the interpenetrations and the jumps, are smoothly managed, very different from the abrupt style of the earlier pieces. Rosenquist is one of the few American artists of the 60s to annex images from high-style Pop culture. The inverted automobile holds the gloss of an ad on coated paper, for all its violent recontextualization. Food, machine, and human image—it is another version of *President Elect* but rendered now with a glittering lyricism rather

than a hard-selling directness. That Rosenquist was conscious of these stylistic differences seems clear from the fact that in the same year he made a bunch of schematic works that derive from low sources in Pop culture. These are *Win a New House This Christmas (Contest)*, *Be Beautiful*, and *Untitled (Joan Crawford Says)*. These are straight examples from the mass media, but each quotation is singular, and unlike Andy Warhol, Rosenquist's best paintings consist of a conjunction of dissimilar images between which the artist elicits not quite evident connections. His structure is like cinematic or photographic montage: the "superimposition of several shots to form a single image" (*The Random House Dictionary of the English Language*, Unabridged Edition).

Diverse materials are added to some of the paintings of 1962–63, such as *Bed Spring*, a cut out canvas stretched with string like a backbreaking trampoline. *Blue Spark with Small Fishpole and Bedsheet Picture*, *Morning Sun*, and *Two 1959 People*, include fishing poles, short boyish improvisations, somewhat Huck Finn-ish. Plastic shreds and pieces are added to other paintings of the time, such as *Early in the Morning*, and *Nomad*. As he attained mastery of his painting skills, Rosenquist was immediately willing to disrupt the homogeneity of the painted surface with raw and loose bits of the world.

Claes Oldenburg

Pop art, used as a comprehensive term, includes expressionist artists as well as the antiexpressionist temperaments of, say, Lichtenstein and Warhol. There are, in addition, expressionist elements that show up variably in early Rauschenberg (pretty clearly derived from de Kooning) and late Johns (apparently generated spontaneously). To indicate something of the expressionist aspects of Pop art, we can approach them by reference to the downtown galleries of New York in the late 50s. There was the Hansa Gallery, a cooperative that included Allan Kaprow and George Segal, which ran from 1952 to spring 1959. Red Grooms, using his studio as gallery space, ran the City Gallery (1958–59) followed by the Delancey Street Museum (1959–60). In 1959, Oldenburg and Dine founded the Judson Gallery and Anita Reuben founded the Reuben Gallery. The Reuben Gallery held one season of exhibitions, 1959–60, but continued for a second season, 1960–61, with Happenings. The artists included Dine, Rosalyn Drexler, Red Grooms, Kaprow, Oldenburg, Lucas Samaras, Segal, and Robert Whitman and the Happenings that were presented included Kaprow's *18 Happenings in 6 Parts* (the first Happening), Grooms' *Fireman's Dream*, Dine's *Vaudeville Act* and *Car Crash*, and Oldenburg's *Ironworks* and *Foto-Death*.[1] The cumulative effect of all this activity is of artists concerned with (1) the human figure, and (2) a particular relationship to the environment. Barbara Rose recorded Oldenburg's interest in an article by Allan Kaprow proposing an interpretation of Jackson Pollock.[2] This was a fruitful misinterpretation of Pollock's drip paintings, as if they were raw samples of the world flowing, as it were, through the paintings. Kaprow

paid no attention to the internal syntax of Pollock, but use his work to write about what he wanted, that is, an art that either extended into or incorporated the surrounding environment.

The transposition of Pollock's allover spatial field into the texture of the world is extraordinarily illuminating. The form that this takes in Oldenburg is linked to his memories of Chicago, where he was born, where he worked briefly as a crime reporter, and to his present experiences of downtown New York. The gritty, worn textures of the man-made city permeate Oldenburg's art. He was aware of Celine, whose name he used in reverse on a plaque, and he planned to do the same for Dubuffet's name. Dubuffet's sense of primal matter, combined in Oldenburg's early work in a way that made the current scene organic and which made Dubuffet's generality highly topical. A core of specific reference acts in opposition to the universalizing spirit of Dubuffet. This sense of the city as an endlessly extendible texture, carrying the traces of age and use, underlies the environmental installation of *The Street*, 1960, at the Reuben Gallery. It is a sustained mixture of the properties of painting, inscription on a two-dimensional surface, and of sculpture, shaped boundaries and three-dimensional projection, the haggard figures and fragmented architecture making a simulated Bowery. *The Street* is parallel to, but not quite the same as, the annexation of used objects from the environment, as in Rauschenberg's early combine-paintings. Some of the difference can perhaps be sensed in a poem of Oldenburg's, one of many written at this time, based on the city:[3]

> from distances
> engines cry their way to me
>
> houses parade rose in the charmed dawn
>
> sharp morning says:
> in whiskey's waterfall, the hail of teeth

Oldenburg's identification with the environment brings out its pathos. This is the basis for the later metamorphic imagery that is central to the meaning of Oldenburg's art. Here, in the form of an identification with the aged, the degraded, the defeated, it is the initial statement of Oldenburg's view of the world as a continuum of differentiated but exchangeable forms.

The kind of immersion by art that Kaprow attributed to Pollock's allover paintings was realized by Oldenburg, working on his own terms, by stressing participatory situations. In 1961, Oldenburg rented a storefront at 107 East Twenty-first Street, eighty feet long and ten feet wide. As he wrote at the time: "actually make a store!," "the whole store an apotheosis."[4] In the front of the store was a counter with objects made by Oldenburg: fragments of signs, clothing, food. After the ominous charred monochrome of the street, the color is fresh and flashy; and the surfaces are rough and solid compared

86. Claes Oldenburg. *U.S.A. Flag.* 1960. Muslin soaked in plaster over wire frame, painted with tempera. 24 x 30 x 3½. Collection of the artist.

87. Claes Oldenburg. *Store Ray Gun.* 1961. Muslin soaked in plaster over wire frame, painted with enamel. 29¾ x 35⅛ x 9. Collection of Letty Lou Eisenhauer, New York.

to the earlier fragile cardboard, burlap, and newspaper pieces. The objects were made in the back of the store and then moved forward for display and sale, thus presenting a situation in which the means of production and distribution are in one man's hands, without the intervention of a dealer. The works of art that were for sale are manic transformations of the kinds of merchandise actually sold and the display signs in real stores: *39¢, 7-UP, Auto Tire and Price, Fur Jacket, Iron, Dresses, Shirts, Pie a la Mode*, and so on. This vernacular iconography is precisely what Oldenburg needed to precipitate his imagination into transforming sequences and exchanges. From notes written in 1961 we can derive a clear notion of a principle of metamorphosis. In fact, so abundant and accurate is his writing that his commentary is practically preemptive. "My work is always on its way between one point and another," he wrote, and here are examples: "Earrings-Airplane Wheels-Brassiere-Breasts" and "cock and balls equals tie and collar/equals leg and bra equals stars and stripes."[5] The lines that lead from earrings to breasts and from cock and balls to stars and stripes are clear evidence of Oldenburg's view that "The erotic or the sexual is the root of 'art,' its first impulse."[6] Both an interest in vernacular iconography and in giantism are characteristic of Oldenburg, Lichtenstein, Rosenquist, and Warhol. Lichtenstein's enlarged whole objects and Warhol's enlarged soup cans show the object in isolation. Rosenquist's close-ups of details present an estranged view of common objects. In Oldenburg, however, the objects are in metamorphosis, each stage of their change allusive of other points in the chain.

In 1961, Oldenburg wrote a Walt Whitmanesque series of affirmations about the relation of art to the quotidian world. "I am for the art of underwear and the art of taxicabs. I am for the art of ice cream cones dropped on concrete. I am for the majestic art of dog-turds, rising like cathedrals."[7] The objects that he made at this time come from this openness to the American experience, no longer experienced desolately but in terms of a great appetite, both for things themselves and for their correspondences. Painting and sculpture collide in the store: as solids, the objects are ripe and distended; the polychrome, however much it supports our recognition of the solid object, often ignores its boundaries and has its own plangent effect. Thus color can become, as Oldenburg defined it: "a chunk in space."[8] There is an exultant over-emphasis in these objects; they are tumescent and substantially present, raided from Fourteenth Street, but also convoluted with analogies. One of the ray guns, for example, is not only like a toy gun, it is like a naive sign for a real gun, and of course, following the title, it is a ray gun, the futuristic shaping of which is blunted by the party-like colored surfaces but which leads to the terminus of this chain of associations, the cock and balls. It is a sign of Oldenburg's eloquence that in the ray gun sculptures; and in related drawings, the guns vary from amorphous clots of plaster to grandly structured emblems. In all of them, however, the themes of childhood play and masculine virility are resourcefully maintained and varied.

The environmental concerns of Oldenburg were shown at the store, not only by the display of sculpture in a merchandising situation but by the

88. Claes Oldenburg. *Bedroom Ensemble*. 1963. Wood, vinyl, metal, fake fur, and other materials. 204 x 252. Collection of the artist.

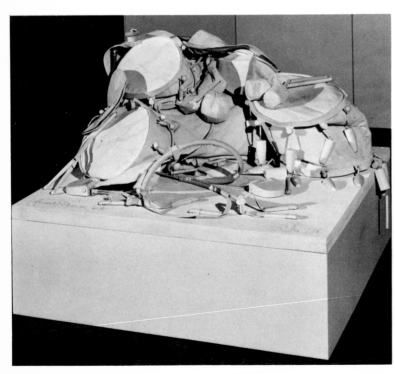

89. Claes Oldenburg. *Ghost Drum Set*. Wood on canvas painted with Liquitex. 72 x 72 x 28. Collection of the artist.

performances of the Ray Gun Theater in early 1962. The style of these pieces recalls the earlier period of *The Street* rather than that of the store in which they were performed. Oldenburg rejects the term *Happenings* and prefers to call his performances "theater of the real" or "theater of objects." The animation of objects and the dehumanizing of people is very different from the aggressive elation of the objects. After the tight-packed, claustrophobic store his next environmental piece was spacious, though eerily so, and instead of being sweatily handmade, like the objects of 1961–62, was constructed from Oldenburg's designs. The *Bedroom Ensemble*, 1963, is a motel room, "apotheosized" (this is Oldenburg's word), in wood, formica, and vinyl. It has built-in perspective distortions, that cause the bed to slant away from our own space, so that our initial impression of familiarity is warped. In the store period, Oldenburg is handling low, popular culture, in terms of brightly colored goods, big price tags, and gooey food, the social equivalent of Warhol's *Before and After* paintings, for example. Here he takes a middle-class American room and magnifies its physical properties of angular structure and plastic surface. The room connotes both the fetishism and hygiene of American life, as well as the desolate calm that characterizes museum reconstructions of period rooms (and the *Ensemble* is always seen in either a gallery or a museum). Ellen Johnson has quoted Oldenburg to the effect that figures appear in the work only "as dolls, mannikins, in 'pornography,' as little anonymous figures in architectural models, and always as corpses."[9] The *Bedroom Ensemble*, with its Marie Celeste-like suggestions of a recent presence in the purse and leopard skin coat, is a monumental statement of the Pop art theme, human objects without the human body. The fact that it is a bedroom, the most intimate of living spaces, intensifies this effect.

In 1963, Oldenburg turned to the systematic study of soft forms, in which his wife's sewing (joining the yielding materials together) was important. The first soft vinyl sculpture is *Soft Pay-Telephone* in which the vinyl forms are stuffed, but not tight, with kapok. There are earlier soft sculptures, as in some of the residual objects (spin-off from the decor of the theater pieces, such as *Upsidedown City*, 1962, from *World's Fair II*) but the material, painted burlap stuffed with newspaper, has a low range of possibilities. With cut, sewn, and stuffed vinyl, however, Oldenburg had a material that could be made to correspond to recognizable objects while radically transforming them. The soft telephone not only presents a rigid form as sluggish and yielding, enlargement carries it to the point where the unit is like a female torso with the coin-return slot as a metaphor for the genitals. There is an exchange of the properties of hardware and body-image in which the commonplace and the unanticipated are fused. Soft sculpture can be tailored and glossy, as the phone is, or it can recall *The Street* period, in its battered identity. This is the case with *Soft Manhattan 2—Subway Map*, 1966, in which the train routes are picked out like a harness on the surface of a bag which carries soft, earthy particles of color indicating the postal zones. The sculpture hangs so that the recognizable tongue of lower Manhattan, carry-

103

ing two systems of unconsultable maps, dangles like an ancient corset. As with the coat and purse in the *Bedroom Ensemble*, a human presence is vividly implied. Gravity is a constituent in soft sculpture, completing the pliable configurations that Oldenburg sets up. Instead of resistance to the force of gravity, which rigid upright sculptures have assumed, these objects acquiesce to the tug of gravity, as our bodies do.

Max Kozloff has referred to the soft sculptures as engaged in a process of "almost Ovidian transformation,"[10] a point that can be made by reference to *Shoestring Potatoes Spilling from a Bag*, 1965–66. It is a sculpture which hangs from the ceiling and represents the process of spilling: potatoes fall, in a golden shower, out of the white inverted bag at the top. The use of gravity is thus extended to showing objects falling and coming apart. It is part of a train of thought that includes projects for sculptures of momentary events, such as a *Giant Tube Being Stepped On* and a *Thrown Can of Paint*, both 1969. The sense of a sudden accident, however, is arrested by the metamorphic analogies which, as given by Oldenburg in a sketch, 1966, are: *Plug = legs = shoestring potatoes*. The two prongs of a plug are like legs and a skirt resembles the cover of the plug; thus the potatoes, issuing from the bag are like a motion study of legs active below a miniskirt. To the extent that the leg analog is dominant, we have an image of purposeful activity, but to the extent that the falling potatoes are the dominant reading, we have an image of helplessness and falling.

Andy Warhol

Warhol, alone of the Pop artists, practiced as a commercial graphic artist working directly in the field of Pop culture. Johns and Rauschenberg did some window displays in their early days, but anonymously, whereas Warhol was a successful graphic artist. After 1947 and through the 50s he did illustration for *Mademoiselle* and *Glamour*, Christmas cards, and dust jacket designs. He illustrated Amy Vanderbilt's *Complete Book of Etiquette*, 1952, and his own book *25 Cats Named Sam and One Blue Passing*, a limited edition.[1] He drew shoes, both for I. Miller advertisements and as autonomous graphics. The work for all these projects is based on a delicate, errant line of great decorative charm that is somewhere between Jean Cocteau's fluency and Ben Shahn's wiryness. An exception is the set of Amy Vanderbilt drawings which are done with a clear, hard line, explicatory rather than ornate.[2]

The question is, what did he keep and what did he reject as he moved from Pop culture to Pop art? He changed his style of drawing, abandoning felicities of quirky line and pattern and adopting an inexpressive, unmodulated form, as in *Before and After 3*. This work is halfway between a group of monochrome objects, such as the bare *Storm Door*, 1961, and the comic strip paintings of 1960-61. It joins the concentration of the former with

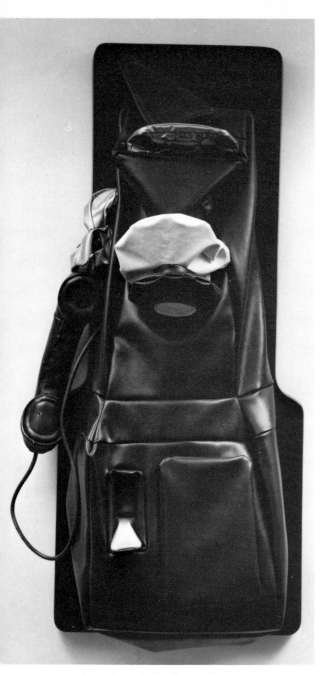

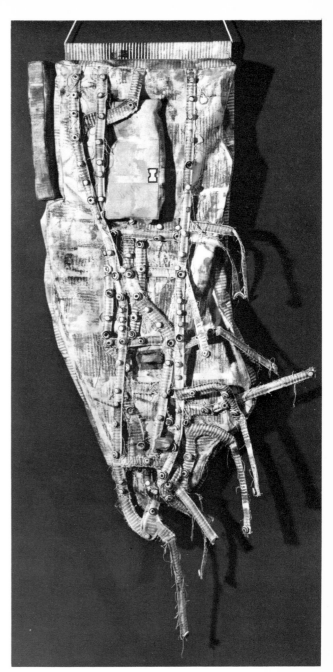

90. Claes Oldenburg. *Soft Pay-Telephone*. 1963. Vinyl filled with kapok, mounted on painted wood panel. 46½ x 19 x 12. Collection of William Zierler, New York.

91. Claes Oldenburg. *Soft Manhattan II, Subway Map*. 1966. Canvas filled with kapok, impressed with patterns in sprayed enamel, wooden sticks, wood rod. 68 x 32 x 7. Collection of Pat Oldenburg. New York.

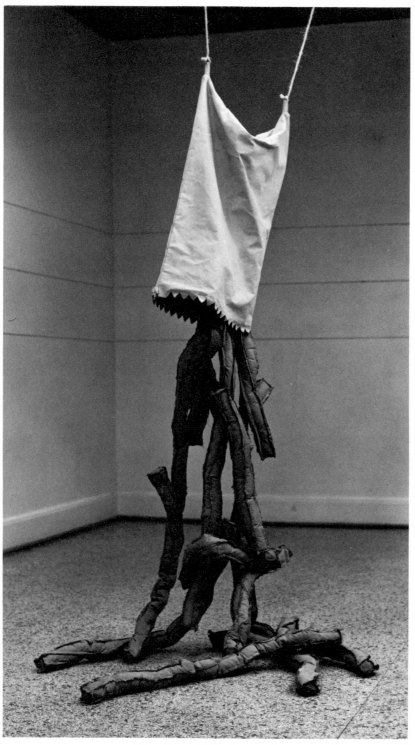

92. Claes Oldenburg. *Shoestring Potatoes Spilling from a Bag (Falling Shoestring Potatoes).* 1965–66. Canvas filled with kapok, painted with glue and Liquitex. 108 x 46 x 42. Collection of Walker Art Center, Minneapolis, Minnesota.

93. Andy Warhol. *Before and After, 3.* 1962. Synthetic polymer on canvas. 74 x 100. Collection of Whitney Museum of American Art, New York; Gift of Charles Simon (and purchase).

94. *National Enquirer,* July 21, 1968. The source of Warhol's *Before and After,* still in use six years later.

95. Andy Warhol. *Dollar Bills*. 1962 (detail). Oil on canvas. 82 x 92. Collection of Mr. and Mrs. Robert C. Scull, New York.

the pictorial quotation of the latter. Enlarged comic strip paintings of 1960 were used in a window display in the following year. They included *Little King, Popeye*, and *Superman*, as well as the first version of *Before and After*.[3] The latter is especially significant, inasmuch as it is a typical image but an anonymous one, whereas the other subjects are all of well known comics figures. *Popeye* is of this group in which casual painting interferes with the strict simulation of the source, suggesting a possible overlapping of expressionistic handling with quotidian references. Thus, neither in the deadpan objects nor the comic strip paintings does Warhol refer to the kind of Pop culture to which he contributed. He switched to, as it were, vigorous "low" sources, away from his commercial genteel style. In a statement of this time, Warhol said: "I adore America and these are some comments on it. My image is a statement of the symbols of the harsh, impersonal products and brash materialistic objects on which America is built today. It is a projection of everything that can be bought and sold, the practical but impermanent symbols that sustain us."[4] The language does not sound authentic, but then most of his statements are unreliable or at least impersonal. However, the content seems correct: American-ness, harshness, expendable symbols.

Warhol's work of the early 60s is diagrammatic in structure, and its subject is always preexisting sign-systems. Dance diagrams and *Do It Yourself* number paintings, sheets of stamps and money, rows of Coca-Cola bottles and Campbell's Soup cans. As John Coplans has pointed out, Warhol begins with freely hand-done paintings, then simulates by hand a machine-printed look, and finally uses silk screens to in fact produce multiple printed images. In some works, the sense of object in the painting is strong, as when a can is torn or bent or pierced by a can opener, but there is a curious ambiguity here. It is true that Warhol presents his image whole, preserving the integrity of objects without interruption or distortion. However, with the Campbell's Soup cans, he is presenting us with the packaging, with the printed wraparound label, rather than the primary cylindrical form of the can itself. This is true of both the 1962 series, which is colored according to Campbell's designer, and the 1965 series in which boutique color is imposed on the normal red and white label. The familiarity of the subject leads us to take as objects what Warhol is actually presenting as signs. Thus information in the paintings equivocates between the real mass of objects and the abstracted continuum of signs. That this is not a side effect of Warhol's art is suggested by the fact that the ambiguity of signs is a constant theme in his work.

The work by which Warhol prefers to be known dates from his use of the silk screen in 1962. Here he selects a photographic image, transfers it enlarged to a silk screen, which can then be put down on the canvas and inked from the back. His subjects—women like Marilyn Monroe, Liz Taylor, and Jackie Kennedy—represent topical climaxes of glamor and also of suffering. The torments of celebrities take place, at least in part, in public, and Warhol is a master of the goldfish-bowl effect that modern communication has produced. Another theme is referred to by the artist himself saying: "My show in Paris is going to be called 'Death in America.' I'll show the electric-chair

109

96. Andy Warhol. *Marilyn Monroe Diptych*. 1962 (detail). Acrylic on canvas. 82 x 57. Collection of Mr. and Mrs. Burton Tremaine, Meriden, Connecticut.

97. Andy Warhol. *Campbell's Soup Can*. 1964. Silk screen on canvas. 36 x 24. Collection of Alberto Ulrich, Milan, Italy.

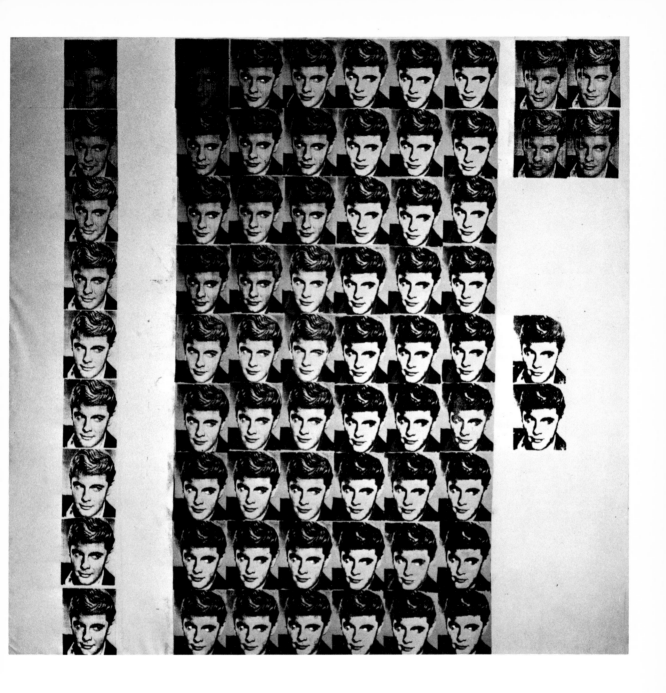

98. Andy Warhol. *Troy*. 1962. Liquitex and silk screen with acrylic on canvas. 83 x 84. Collection of E. J. Power, London, England.

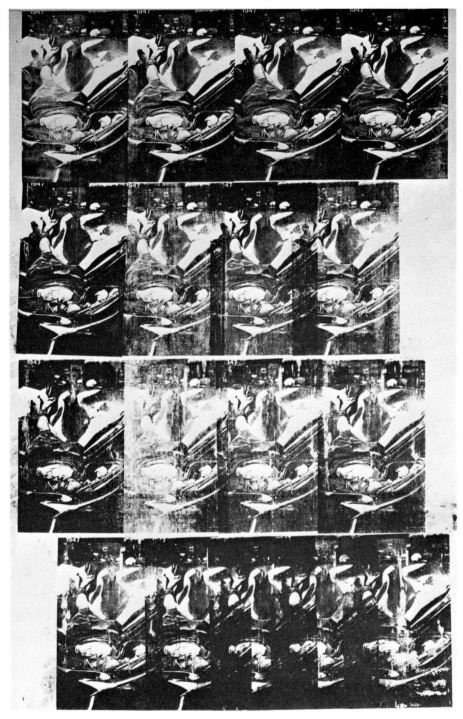

99. Andy Warhol. *1947–White*. 1963. Silk screen on canvas. 121 x 78. Collection of Luciano Pomini, Castellanza, Italy.

pictures and the dogs in Birmingham and car wrecks and some suicide pictures.''[5] The exhibition did not have a title, but this is an accurate account of Warhol's Disaster paintings. He depends on the mass media to provide images of spectacular exits from the world, just as he did of its painful occupancy. Death, as Warhol depicts it in his selected photographs, is statistically average; the car crashes are those that any of us might be in. The goldfish bowl in which death and catastrophe occur includes us, the spectators.

According to the amount of ink a print uses, according to the amount of pressure with which it is applied, the silk-screen image will vary through its repetitions. The *Marilyn Monroe Diptych*, 1962, is a good example of the variety that comes from this apparent mechanization of picture production. One panel is a blaze of bright, glamorous color, the other is printed in black, with some images of her head clotted in paint and other images present only as a dry trace on the canvas. The nuances of each image are as evident as the repetition which is what has been over-stressed in criticism of Warhol. As usual with him, each image is a whole; yet each one is subject to gradual or abrupt variation. In a curious way, the shift from image to image constitutes a kind of covert return to the characteristics of autographic touch, one of the traditional functions of which was to provide just this kind of unpredictable sensuous departure from a norm. The wholeness of the image, known or at least familiar in type, is central to Warhol's art and can be seen by comparing two uses he made of the Mona Lisa. In *Thirty Are Better Than One*, 1963, there are five rows of six Mona Lisas each; in *Mona Lisa*, 1963, the images are scattered, not serial, with complete color change; some images are tilted, and in addition, two details of the painting are added. The result is a jumpy and restless composition, in which the Mona Lisa's status as a cliché of twentieth-century art is celebrated. The thirty Mona Lisas stacked in alignment, however, has an hypnotic calm which makes the annexed image comparable to Marilyn or the soup cans.

Warhol is reported as saying, concerning his use of silk screens: "I think somebody should be able to do all my paintings for me."[6] Nonetheless, Warhol is present in the selection of the image to be printed, and his own earlier work sets the formal patterns to be followed; it is in the context of his own work that his art has meaning, and not as the art of somebody working for Warhol. It should be remembered, too, that the scale of the production process, occasional output from a single studio, puts it in the category of cottage industry, not of mass production. The over-quoted tag of Warhol's, "I think everybody should be a machine"[7] needs to be compared to the real facts of his production. The appearance of anonymity, of acceptance of the given, is essential to his work, but it is a personal form of anonymity, not to be confused with Lichtenstein, despite *his* professed impersonality.

The difference between Duchamp and Warhol helps to define the latter. Duchamp used the ready-made as an aggressive insertion into the field of art. Warhol uses the ready-made, such as a photograph from the public domain, to saturate his art with life's traces. The texture of visual and social reality that photographs convey is an essential part of his art. Warhol and

113

Rauschenberg, in their silk-screened paintings, both depend on the equation of photographic textures with real world events. This began with nineteenth-century newspaper photographs and was continued by twentieth-century picture magazines; the movies and TV have, in different ways, maintained the idea of photography as the most evidential channel of communication. The fading or loss of detail that occurs within silk-screened images is like life itself when it has been photographed and reproduced. A uniform tessela-tion of not-quite-identical images characterizes the internal order of Warhol's best paintings. In addition, the repetition of imagery from one work to another produces an effect of proliferation, as his module is extended beyond the borders of single works. Thus, no one painting can exhaust an image's mean-ing; each painting is part of a group that extends into the world beyond its edges. It is this sustained flow of images that acts as a metaphor, though not as the fact, of mass production.

4. CONTEXT

Pop art has often been regarded as a self-contained indigenous movement, with a life-span of a few years, occurring in the late 50s and early 60s. It is true that this is the period in which it was most conspicuous as a group, and it is true that there are specifically American components. However, after the achievement of abstract expressionism, subsequent artists could not be satisfied with local references alone. The abstract expressionists had not only asserted the power of American painting, they had appropriated and reinterpreted earlier international modern art, which is to say, European art. Therefore, Pop art needs to be considered in relation to other groups in the twentieth century to see what links and what differences emerge. For example, both futurism and purism were expressly pro-urban and protechnological—obviously an attitude of relevance to some Pop artists. The futurists celebrated the city, the crowd, as opposed to the individual, and extended the post-impressionist iconography of Parisian night life. The extraordinary opening of the first manifesto of futurism includes an account of an automobile accident, treated as an exhilarating experience. There cannot be many such incidents in literature before 1909.[1] Essential to the program of purism was the assimilation of mass-produced objects into still-life painting. "Purism has brought to light the *law of mechanical selection*. This establishes that objects tend toward a type that is determined by the evolution of forms between the ideal of maximum utility, and the satisfaction of the necessities of economical manufacture, which conform inevitably to the laws of nature."[2] Hence the stacks of identical plates or the cool profile of a thermos flask, in place of the unique and handcrafted articles of earlier still lifes, are to be regarded as naturally geometric: the production line and universal law are compatible.

What unites both movements—one enthusiastic and celebratory, the other grave and classicizing—is the artists' acceptance of both urban life and modern technology. The theaters and cabarets of Degas and Toulouse-Lautrec,

115

illuminated by gas and attended by a democratically expanded audience with leisure, depict the results of mass production but do not go beyond this. The futurists and the purists, however, leave no doubt as to their confidence in the industrial infrastructure of city life. Dadaism, too, has an urban content; the objects that dadaists deploy (a bicycle wheel or a bottle rack) are inconceivable in a low-waste agricultural economy, for example. It is not my purpose to cite every city view as an incipient anticipation of Pop art. Expressionism, of course, had its urban scenes (derived from van Gogh and Munch), sometimes as part of the spectacle of modern life, sometimes as a desolate image of the human condition. The earlier works of Die Brücke show both forms, but the later work is largely pastoral and universalizing, in which the group comes to resemble the artists of Der Blaue Reiter, whose aim was the transcendence of objects in the world.

In addition to the high index of urbanism in futurism and dadaism, there is another factor which must be taken into account, and that is the interplay of visual and verbal elements. F. T. Marinetti argued for an antisyntactical use of language, "words-in-freedom,"[3] in which he brought the free verbal layout of symbolist posters such as Toulouse-Lautrec's to poetry. The scatter of words in space was not restricted to futurist writers but was taken up by the artists who used words with a semi-ideographic solidity within the pictorial context of paintings. The pictorialization of words and the mixing of visual and verbal systems of representation are major resources of Pop art. It is not that the Pop artists are direct descendants of Marinetti, but rather that Pop art, as an alternative to abstract art and formalist aesthetics, has points of contact with other expansionist artists.

This matter is important because twentieth-century art is often described as essentially devoted to the definition of art in terms of media purity, as visual objects without literature, without ideology. The idea, established in the eighteenth century, of the separation of the arts from one another has been rigidly maintained, primarily to justify abstract art. The presumption is that only in abstract works can the distilled visuality of painting be clearly seen. This view, which is widespread, has had the effect of closing off alternative approaches: the diversity of twentieth-century art has been drastically reduced. The theory requires that those artists who are not abstract be considered off-center and out of the mainline of absolute structure, though redemption is possible for figurative artists who emphasize formal devices (flatness and composition) over iconography. The interpenetration of visual and verbal forms is, in effect, a mixture of channels such as formalist critics reject as a violation of the unified membrane of painting. However, it is a constituent of twentieth-century art, a theme that the American painters share with their predecessors. The fact that word and image function differently in Pop art is to be expected but does not break the continuity of motif proposed here.

Fernand Léger, le Corbusier, and Ozenfant were responsible for an influential set of ideas in the 20s. Léger wrote: "No more cataloging of beauty into hierarchies—that is the most clumsy mistake possible. Beauty is every-

116

where, in the arrangement of saucepans, on the white wall of your kitchen, perhaps more there than in your 18th century salon or in official museums."[4] He praises window displays and gives an appreciative account of a store keeper with "seventeen waist coats to display in his window, and just as many buttons, cuffs, and ties to fit round them."[5] It is in the same article that he makes his famous comparison between the paintings in the Salon d'Automne and the machines in the Salon d'Aviation and preferred the latter. In *La Peinture Moderne*, published by Ozenfant and Jeanneret (le Corbusier) in 1926, we find this assertion of the geometrization of our environment: "the hours of our day are spent amid a geometrical spectacle, our eyes are subject to a constant commerce with forms that are above all geometry."[6] In the following year, the American painter Louis Lozowick makes a similar point: he detected an "order and organization which find their outward sign and symbol in the rigid geometry of the American city: in the verticals of its smoke stacks, in the parallels of its car tracks, the squares of its streets, the cubes of its factories, the arc of its bridges, the cylinders of its gas tanks."[7]

Thus purist geometry is Americanized, and it does not matter here whether Lozowick knew Ozenfant's and le Corbusier's book, much of which had appeared earlier in their journal *L'Esprit Nouveau*, 1919–25. In any event, it is a commonplace idea, but it is useful in that it enables artists to unite formal rigor with an imagery that refers unmistakably to familiar objects. Gerald Murphy, the recently revived American painter of the 1920s, held similar ideas. He sought a "balance between realism and abstraction," and the latter term was "nourished on Léger's, Picasso's, Braque's, and Gris' abstractions."[8] Murphy was a prompt and able American equivalent of purism (with which, via le Corbusier, Léger can be related).

In general, the immaculates in the United States explored the double possibility offered by the conflation of geometry and external subject matter. For the attention they paid to man-made forms and for their interest in what is called an impersonal technique, the immaculates seem possible predecessors of Pop art.

Murphy, Charles Sheeler, and Charles Demuth, in particular, retained an American specificity of reference within their formal patterns, compared to, say, Niles Spencer whose level of generalization is consistently higher. There is, of course, one point of incontestable contact between the immaculates and Pop artists: Charles Sheeler's *I Saw the Figure Five in Gold* (a portrait of William Carlos Williams) has been quoted by Jasper Johns in *Figure 5*, 1955, and *Figure 5*, 1960, and by Robert Indiana in *The Diamond Five*, 1963. The original painting is one of a set of seven in which Sheeler selected and arranged objects which he associated with the personalities of his friends. They are an extension of Marsden Hartley's *Portrait of a German Officer*, 1914, into still life, but with the additional influence of Picabia's and Duchamp's mecanomorphic portraits in which machine forms signified human presences. Demuth, with characteristic irony, referred to these works as "posters."[9] In them words are as emblematic of character as the depicted objects, a definite link to the words, numerals, and letters abundant in Pop art.

117

In 1964, at a time when the comics source of his art was overwhelmingly evident, Lichtenstein declared that "the formal statement in my work will become clearer in time."[10] He was right, but in addition, he has himself emphasized increasingly the formal aspects of his later work. In 1966, referring to the designs by others from which his paintings were derived, he was quoted as saying: "The result is an impersonal form. I would like to bend this towards a new classicism."[11] The idea of modern art as a new classicism has a history, and Lichtenstein's *Modern Paintings* series (1966–70) recognizes it. John Golding has discussed Léger's participation in the rationalistic ambiance of Parisian art—the 20s, in which disciplined design was identified as a symbol of universal order. This way of thinking seems fairly close to that of Lichtenstein. In a 1967 interview he remarked: "Recently I have been tempted to do a Léger. . . . He really isn't someone I think I am like, yet everyone else thinks I am like him. I can see a superficial relationship; for obviously there is the same kind of simplification and the same kind of industrial overtones and clichés."[12] Lichtenstein did not go straight to Léger but approached him via the decorative arts of the 20s and 30s to which, of course, Léger is affiliated. As Lichtenstein carried design motifs of the period into easel painting he activated, for those who had not noticed it, an Art Deco potential in Léger's work. Without quoting him directly, as he had cited Cézanne and Picasso, Lichtenstein alludes to Léger in the *Modern Paintings* as a model of style, as a type of archaic modernism. Finally in 1973, Lichtenstein quoted Léger directly, in the form of a reproduction in a group of studio wall paintings (which also allude to the rack pictures of nineteenth-century *trompe-l'oeil* painting).

In sum, Lichtenstein's compositional sense, his economy, and his apparent impersonality seem to derive from the classical-industrial equation of purist and precisionist art. Custom forces me to add that to say this is not to indicate a weakness of some sort, but merely to identify one of the components in a complex work. The total expressive meaning of individual works and the work as a whole should not be construed as explainable by this historical debt. The early distinction Lichtenstein made between forming and transforming is evidence of classicizing theory, but it does not, in fact, inhibit his practice. In 1963 he stated: "Transformation is a strange word to use. It implies that one transforms. It doesn't, it just plain forms."[13] A more accurate statement of his operations is in a statement of the following year: "In my own work there is a question about how much has been transformed. You will discover the subjects really are [transformed] if you study them, but there always is the assumption that they are the same only bigger."[14] Once transformation was admitted, Lichtenstein may have feared that his detachment, his personal form of anonymity, would be reduced. In fact, once the process of transfer, and the inevitable adaptation of the originals is in the open, it is clear that Lichtenstein is not consigning raw material directly to an art context. He is making a double image in which his art and the quoted art or channel, are inextricable.

H. H. Arnason has observed of Stuart Davis that "while his motivations differed in many ways from those of young Pop artists, there can be no ques-

118

tion about his influence on them."[15] The kind of painting Arnason may have had in mind would be *Lucky Strike*, 1921, but it must be noted that the pack is not viewed head-on, but tilted. The absence of frontality suggests a reminiscence of cubism more than an anticipation of Pop art. An untitled painting of 1924 of a bottle labeled *Odol "It Purifies"* is closer to the stylistic form of Pop art, but it is overlaid by a slanted, transparent rectangle, a cubist device, which is just what a Pop artist would have avoided. It is true that street signs, packages, and window displays are evoked as a lively spectacle, but the scale of Davis' represented objects and the web of their interrelations is basically that of a painter whose conception of space is both late cubist and scenic. He presents a space which, though somewhat flattened, invites entering. The picture space is like a parking lot, the aisle of a store, or the foyer of a movie theater, with a strong invitational character. In Pop art, however, there is less residual landscape space or tabletop space: Davis is in the supermarket, but as a visiting cubist. In addition, Pop artists have been much concerned with the opacity of objects, with their factual presence, and their semantic ambiguity. Davis, on the other hand, is confident that "an artist who has traveled on a steam train, driven an automobile, or flown in an air plane doesn't feel the same way about light and color as one who has not."[16] This technological optimism is not something that the Pop artists share; at ease with the objects of mass production as they are, they are not celebrating the early twentieth-century idea of a "new spirit" or "modernity." Davis' ideas really belong to the cluster of theories and attitudes dominated by Léger and purism. Though he substituted English for French words in his late cubist paintings, his American-ness was not of particular help to Pop artists. Those who were interested in geometries preferred Léger (in the case of Lichtenstein) and Sheeler (in the case of Indiana).

The Eight, the so-called Ash-Can School, can be mentioned, not for direct influence on Pop art but to indicate a possible American trait that appears in both groups. Four of the members of the group worked for Philadelphia newspapers in the 1890s. Before photographs, when artists drew for newspapers, they needed a talent for fast, accurate sketches and a good visual memory. When they turned from illustration to painting, as William Homer Innes has pointed out, they possessed an uninhibited nonacademic drawing style[17]. There was more than that: reporting had also expanded the range of urban subject matter that they felt able to paint. Their reportorial experience made them sharp image makers, sensitive to the characteristic gestures of age, class, and occupation, as well as to the pictorial possibilities of the El and rooftop society. Thus they absorbed topical subjects into art with less than the customary formality of the period and enjoyed the everyday for its inherent vitality and solidity. John Sloan, for instance, recorded "the necessity of working from the 'commonplace' and the familiar world of one's native land."[18] Barbara Novak observes, apropos of these city subjects: "The revolution in subject itself, with its hindsight gained from the Pop art of the 1960s, seems of importance."[19]

Leo Marx has characterized an aspect of American literature (he was writ-

119

ing about Mark Twain and Walt Whitman) as deriving from "the extraordinary sense of immediacy that its vernacular conveys."[20] To transfer this concept from verbal to visual emphasizes the degree to which the local and topical references that occur in Pop art have precedents in American art. In particular, nineteenth-century *trompe-l'oeil* painting is relevant: here the vernacular quality is carried both by the familiarity of the objects shown and by continuities from representation to the illusion of actual presence. The play of illusory forms has a connection to one's sense of wonder, but it is important to bear in mind that our wonder concerns the objects of everyday life. To make the illusion possible, William Harnett and the others had, of course, to create a shallow space and to close it, with a door or a wall parallel to the picture plane. The objects within this delimited zone could then be solidly realized, while, at the same time, a version of the flatness that has preoccupied twentieth-century painters is also accidentally achieved. Painted objects the same size as life and flat planes coincident with the picture surface and the picture edges are common to both *trompe-l'oeil* and Pop art. In addition, there is the apparent withdrawal of the artist from the work. In different ways, Lichtenstein and Indiana by their tidy surfaces, Warhol and Rauschenberg by the mechanical look of photographic silk-screened images, seem physically absent from the work, compared to, say, their gestural predecessors, such as Pollock or de Kooning. Similarly, the *trompe-l'oeil* artists dazzle us with their powers of deception which depend, in part, on curbing autographic brushwork so that we may see the work of art as an object or the objects it depicts absolutely clearly. The money imagery of Hefferton and Dowd, of Warhol and Lichtenstein, continues the classic *trompe-l'oeil* gag of illusionistic money, probably begun, according to Alfred Frankenstein, by William Harnett's *Five Dollar Bill* of 1877.[21] It is hard to look at John Haberle's *Slate*, ca. 1895, without thinking of Jasper Johns' early tablets, such as *Tango*, 1955. The canvas area simulates the area of the slate; it is headed with a painted legend "memoranda," and carries messages. Seemingly in front, hangs a crayon on a string, which brings up additional memories of later Johns, such as *No*, 1961, or *Fool's House*, 1962, with their suspended attachments.

To what extent were the Pop artists aware of the nineteenth-century illusionists? Harnett was not obscure, interest in him having been revived in 1939 by an exhibition at the influential Downtown Gallery. It is always a risk to assume that an artist knows the same sources that a writer does, especially at a distance of nearly twenty years, but I see no obstacle to the Pop artists finding out about, or simply coming across, nineteenth-century *trompe-l'oeil* in the 50s.[22] Roy Lichtenstein's work of the early 50s includes legible paraphrases of nineteenth-century pictures by, among others, Charles Willson Peale and William Ranney. Such works suggest that Lichtenstein was in pursuit of American themes and experimenting with the possibility of achieving this aim through adopted imagery. Thus his rickety, Picassoid lithograph of a ten dollar bill, 1956, alludes to nineteenth-century money paintings even as it twists away from them. His later paintings of *Stretcher Bars*, 1968, in which the front of the canvas is an image of the back, picks up a *trompe-l'oeil* theme with con-

120

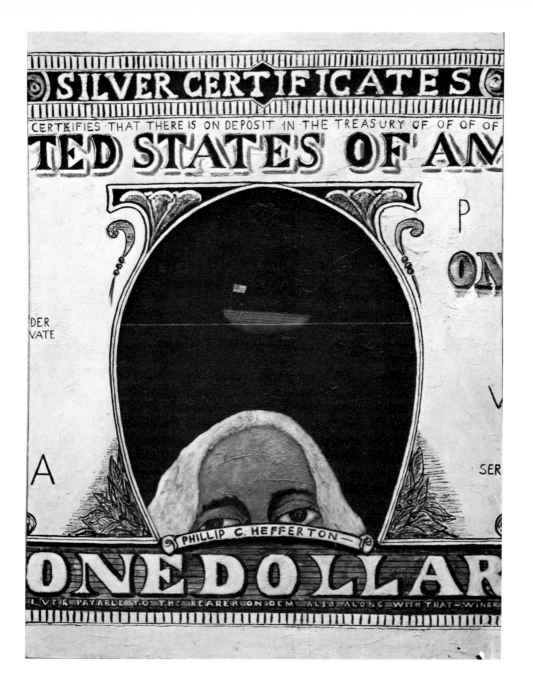

100. Phillip Hefferton. *Sinking George.* 1962. Oil on canvas. 90 x 67½.
Collection of Betty and Monte Factor family, Los Angeles, California.

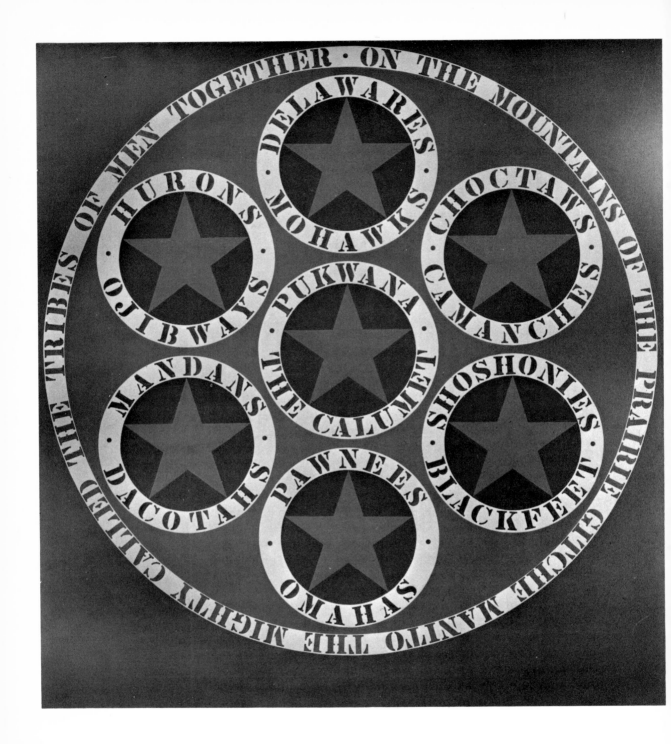

101. Robert Indiana. *Year of Meteors*. 1961. Oil on canvas. 90 x 84. Collection of Albright-Knox Art Gallery, Buffalo, New York.

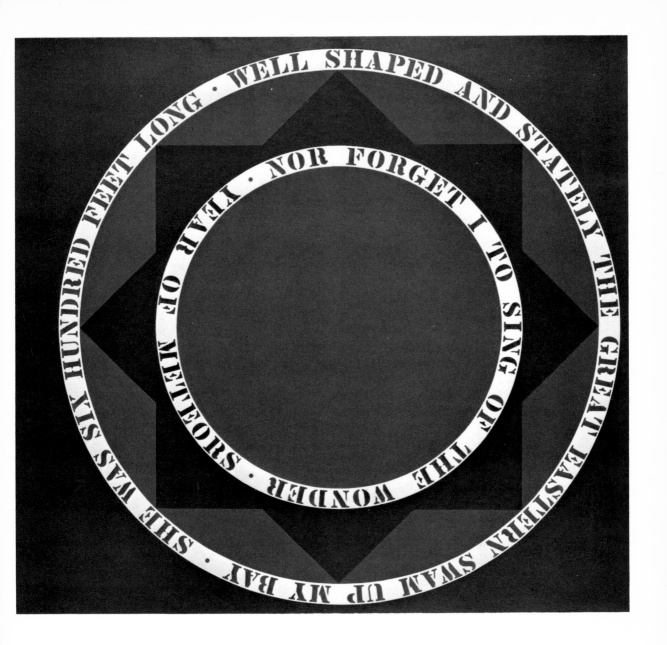

102. Robert Indiana. *The Calumet.* 1961. Oil on canvas. 90 x 94. Collection of Rose Art Museum, Brandeis University, Waltham, Massachusetts.

103. Anon. American, mid-nineteenth-century trade sign. Painted wood. 38 x 30½. Shelburne Museum, Vermont.

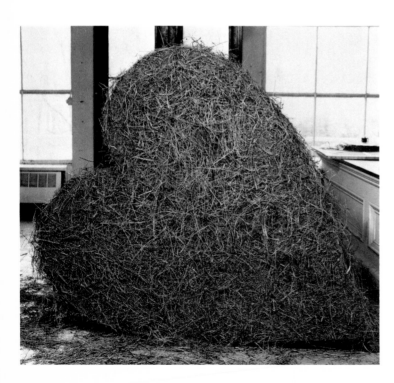

104. Jim Dine. *Nancy and I in Ithaca (Straw Heart).* 1966–69. Sheet iron and straw. 60 x 70 x 12½. Collection of Sonnabend Gallery, New York.

scious assurance. Referring to William M. Davis' *A Canvas Back*, Frankenstein writes: "The idea, of course, is to make the spectator think he is contemplating the back of a canvas. . . ."[23]

It is probable, then, that knowledge of relevant predecessors was available to Lichtenstein, as it was to Indiana with his knowledge of nineteenth-century trade insignia and his quotations from Whitman. The use of motifs from the urban environment; survivals from the last century, in Indiana's case; current images in the case of Lichtenstein's use of comics and advertisements is vernacular in derivation, a fact which persists, however formalized their transposition into new paintings. Indiana's *Year of Meteors*, 1961, takes words from a poem by Whitman: "Well shaped and stately the Great Eastern swam up my bay . . ." The poem celebrates the time 1859–60 and the coincidence of a meteor shower with the transatlantic crossing of the ship, *The Great Eastern*. The painting was done close enough to a hundred years later, and the artist regarded it, in some degree, as a centennial gesture, commemorative in function. The artist lived then in Coenties Slip, the end of which gives onto the East River, along which *The Great Eastern* presumably sailed when she reached New York. Here the painting is a cluster of personal references to Indiana, and the act of painting the work, as well as learned references to Whitman, the two levels of reference bound together by the shared urban environment.

New movements make better news than young artists individually, and Pop art—though it does represent a convergence of interests—was a temporary coalition at most. However, the apparent cohesion of a group of artists working in a common area is usually exaggerated at the expense of their differences. With the relaxation of the group sense, there is a tendency for those who think in terms of the evolutionary succession of movements to pronounce it dead. However, I hope enough has been said here to show (1) that Pop art, though not a strict movement, consisted of artists with overlapping interests, and (2) that their work has prospered, on the basis of interests established earlier, beyond the effective period of group identification. There have been several attempts to discount the referential aspects of Pop art, one of which might be discussed here. "Pop imagery may be momentarily fascinating," according to Robert Rosenblum, but "the most inventive Pop artists share with their abstract contemporaries" a taste for "rows of dots, stripes, chevrons, concentric circles"[24] and so on. He cites Indiana's connections to Ellsworth Kelly as evidence that "the boundaries between Pop and abstract art keep fading."[25] The error of this view, the isolation of formal devices, is a common one in American art criticism, and it has a special disadvantage for Pop art. This approach, by reducing the importance of iconography, discounts the complexities of signifier and signified which, it has been argued, constitute the core of Pop art.

It is to the point to note that the Pop artists have been highly productive. Their personal developments show them to have accumulated relevant meanings around their original themes and to have systematically extended both motif and structure. Pop art turned out to be an art of developable ideas.

125

We can conclude from this that the individual talents of the Pop artists, which were considerable, have been legitimated by their culture as representative of a certain view of culture and the world. The generative nature of their initial ideas received, also, another kind of confirmation supplied by the booming economy of the 1960s. We can say, therefore, that the Pop artists began with good ideas, sustained them from the late 50s to the present time, and in this period, won fast acceptance of their art in the art market. Hence, their conspicuous presence in museums. It is of such confluences of talent and connection, artistic timeliness and success, that history is made. It is, I know, not usual to record the early success of an avant garde where struggle and misunderstanding is expected, but what we have with the Pop artists is a situation in which success has been combined with misunderstanding.

NOTES

INTRODUCTION

1. This project, *Addendum to Pop, 1964,* was not exhibited until 1971, when photostats of the copyrights were shown at Billy Apple's loft, 101 West Twenty-third Street, New York.
2. Lawrence Alloway, "The Arts and the Mass Media," *Architectural Design* (February 1958): 84–5.
3. *The Wall Street Journal,* February 16, 1967, p. 1.
4. The term appeared in 1959 (Kaprow's *18 Happenings in 6 Parts* at the Reuben Gallery) and proliferated in the 60s. Pop art and Happenings are often treated together as object-based and performance-based aspects of an environmental sensibility.

1. DEFINITION

1. Paul Oscar Kristeller, "The Modern System in the Arts," *Renaissance Thought,* vol. II (New York: Harper and Row), 1965, pp. 163–227.
2. E. H. Gombrich, "Imagery and Art of the Romantic Period," in *Meditations on a Hobby Horse* (London: Phaidon Press, 1963), pp. 120–26.
3. Robert Rauschenberg, *Oyvind Fahlstrom* (Paris: Daniel Cordier Gallery, 1962).
4. "The Painter and the Photograph," text by Van Deren Coke (Albuquerque: University of New Mexico, 1964), p. 6.
5. For a chronology of the Reuben Gallery, see the author's "Eleven from the Reuben Gallery" (New York: Solomon R. Guggenheim Museum, 1965).
6. "Ten from Rutgers University" (New York: Bianchini Gallery, 1965). Artists represented: George Brecht, Geoff Hendricks, Allan Kaprow, Gary Kuehn, Roy Lichtenstein, Philip Orenstein, George Segal, Steve Vasey, Robert Watts, Robert Whitman. The catalog includes a chronology.

127

7. Research on *Fluxus* started in the 70s, but in Europe rather than the United States. See ''Happening and Fluxus'' (Cologne: Kunstverein, 1970).

8. Kenneth Koch, ''George Washington Crossing the Delaware,'' in Michael Benedikt, *Theatre Experience* (New York: Doubleday, 1967, pp. 175–96.

9. Sam Hunter, *Larry Rivers* (Waltham, Massachusetts: Poses Institute of Fine Arts, Brandeis University, 1965).

10. Daniel Robbins, *Albert Gleizes* (New York: Solomon R. Guggenheim Museum, 1966). Daniel Robbins, *Le Prix Astor Cup ou les Drapeaux*, 1915 (New York: Solomon R. Guggenheim Museum), p. 71.

2. SIGNS AND OBJECTS

1. ''New Realists,'' texts by John Ashbery, and Pierre Restany, and Sidney Janis (New York: Sidney Janis Gallery, 1962).

2. Ivan Karp, ''Anti-Sensibility Painting,'' *Artforum* 2, no. 3 (Sept. 1963): 26–7.

3. Pasadena Art Museum, 1962, ''The New Painting of Common Objects,'' an exhibition arranged by Walter Hopps, was the first museum showing of Pop art. It was followed in 1963 by ''6 Painters and the Object'' at the Solomon R. Guggenheim Museum, arranged by the author. In April of that year there were three exhibitions: ''Popular Art'' at the Nelson Gallery, Atkins Museum, Kansas City, Missouri, arranged by Mr. and Mrs. Charles Buckwalter; ''Pop Goes the Easel'' at the Contemporary Art Museum, Houston, Texas, arranged by Douglas Macagy; and ''The Popular Image'' at the Washington Gallery of Modern Art, arranged by Alice Denney. When ''6 Painters and the Object'' was shown at the Los Angeles County Museum in the summer of 1963, the author arranged an equivalent West Coast exhibition entitled ''6 More.'' ''Pop Art USA'' at the Oakland Art Museum, arranged by John Coplans, followed in September.

4. Two representative proexpressionist figure revival texts are: Peter Selz, *New Images of Man* (New York: Museum of Modern Art, 1959) and *Recent Painitng USA: The Figure* (New York: Museum of Modern Art, 1962).

5. Richard Artschwager, interview, ''The Object: Still Life,'' *Craft Horizons* 25, no. 5 (Sept.-Oct. 1965): 54.

6. Ibid, p. 30.

7. Ibid, p. 30.

8. Barbara Novak, *American Painting of the 19th Century* (New York: Praeger, 1969), p. 23.

9. Ibid, p. 21.

10. ''Brush Strokes of a 4-Stroke,'' *Motor Cyclist* 772 (Feb. 1962).

11. Robert Indiana and Robert Creeley, *Numbers* (Edition Domberger, Stüttgart, Galeria Schmela, Düsseldorf, 1968).

12. Ibid.

13. Robert Indiana. Introduction by John W. McCoubrey (Philadelphia: Institute of Contemporary Art, University of Pennsylvania, 1968), p. 27.

14. For a study of the relations of painting and poetry, see Jean H. Hagstrum, *The Sisters Arts* (Chicago: University of Chicago Press, 1958).

15. Richard Marshall, ''A Conversation with Ed Ruscha'' (1972). Unpublished.

16. Arts Council of the YM/YWHA, Philadelphia (1962). Arranged by Audrey Sobol, et al.
17. Ibid.
18. Søren Kierkegaard, *The Present Age*, trans. Alexander Dru (New York: Harper, Torchbooks, 1962), p. 35.
19. Ibid, p. 40.
20. Ibid, p. 40.
21. Claes Oldenburg, *Notes in Hand* (New York: E. P. Dutton, 1971), unpaginated.
22. Pasadena Art Museum, *Claes Oldenburg: Object into Monument*, text by Barbara Haskell (1971), p. 87.
23. Ibid, p. 92.
24. Ibid, p. 83.

3. ARTISTS

Jasper Johns and Robert Rauschenberg

1. Calvin Tomkins, *The Bride and the Bachelors* (New York: Viking, 1965), p. 213.
2. John Cage, *A Year from Monday* (Middletown, Connecticut: Wesleyan University Press, 1969), p. 4.
3. Robert Rauschenberg, "Random Order," *Location I* 1 (1963): 27–31.
4. Robert Rauschenberg, interview with André Parinaud, *Arts, Letters, Spectacles, Musique*, no. 821 (May 10, 1961): 18.
5. Paul Zucker, "Ruins: An Aesthetic Hybrid," *Journal of Aesthetics and Art Criticism* 20, no. 2 (1961): 119–130.
6. Rauschenberg (Parinaud interview), op.cit.
7. Dorothy Gees Seckler, "The Artist Speaks: Robert Rauschenberg," *Art in America* 54, no. 3 (1966): 76.
8. Rauschenberg (Parinaud interview), op.cit.
9. Bitite Vinklers, "Why not Dante?" *Art International* 12, no. 6 (1968): 99.
10. Robert Rauschenberg, "Oyvind Fahlstrom," *Art and Literature* 3 (1964): 219.
11. Leo Steinberg, *Jasper Johns* (New York: George Wittenborn, Inc., 1963), p. 15.
12. Walter Hopps, "An Interview with Jasper Johns," *Artforum* (March 1965): 34.
13. Marcel Duchamp, "The Creative Art," reprinted in *The New Art* (New York: Gregory Battcock, 1966), p. 23. (From a lecture given in 1957.)
14. G. R. Swenson, "What Is Pop Art?," (Part II) *Art News* 62 (February 1964): 40.
15. Ibid.
16. Jasper Johns, "Duchamp," *Scrap* 2 (1960): unpaginated.
17. Notes by the author in *Harper's Bazaar* (London, February, 1959): 108.
18. Max Kozloff, *Jasper Johns* (New York: Abrams, 1969).
19. Nicolas Calas, *Art in the Age of Risk* (New York: E. P. Dutton, 1969), p. 237.
20. Jasper Johns, "Sketchbook Notes," *0 to 9*, no. 6 (July 1969): 1–2.
21. Ibid.

Roy Lichtenstein

1. For Lichtenstein's sources see Albert Boime, "Roy Lichtenstein and the Comic Strip," *Art Journal* 2 (1968–69): 155–60. Additional examples in *Canadian Art* 1 (1966): 13; Lucy Lippard, *Pop Art* (New York: Praeger, 1966), p. 13; and *Studio International* 896 (1968): 23.
2. Alain Robbe-Grillet in an interview with Paul Schwarz, "Anti-Humanism in Art," *Studio International* 899 (1968): 168–69.
3. Diane Waldman, *Roy Lichtenstein* (New York: Abrams, n.d.), p. 7.
4. Nicolas and Elena Calas, *Icons and Images of the '60s* (New York: E. P. Dutton, 1971), p. 18.
5. John Coplans, *Roy Lichtenstein* (Pasadena, California: Pasadena Art Museum, 1967), p. 16.
6. Ibid, p. 16.

James Rosenquist

1. John Rublowsky, *Pop Art* (New York: Basic Books, 1965), p. 90.
2. Brydon Smith, *James Rosenquist*, catalog for the National Gallery of Canada, Ottawa (1968), p. 88.
3. First version, Ibid., p. 88; second version "An Interview with James Rosenquist" by Jeanne Siegal, *Artforum* 10, no. 10 (1972): 30.
4. Rublowsky, *Pop Art*, op. cit., p. 87.
5. Robert Rauschenberg, "Random Order," *Location* I, no. 1 (1963): 27–31.
6. G. R. Swenson, "What Is Pop Art?," (Part II) *Art News* 62 (February 1964): 40–43.
7. Marcia Tucker, *James Rosenquist*, a catalog for the Whitney Museum of American Art, New York (1972), p. 16.
8. Gene Swenson, "The F-111," *Partisan Review* 32 (Fall 1965): 51–98.
9. Ibid, p. 599.
10. Nicolas and Elena Calas, *Icons and Images of the '60s* (New York: E. P. Dutton, 1971), p. 122.
11. "Aside from the human face, it originally included some cows, a hand shaking salt on a lapel, a naked man committing suicide." Lucy Lippard, *Changing* (New York: E. P. Dutton, 1971), p. 89.
12. Other paintings are *Gold Star Mother*, *Brighter Than the Sun*, and *Balcony*.
13. Tucker, *Rosenquist*, p. 17.
14. Lippard, *Changing*, p. 195.
15. Tucker, *Rosenquist*, p. 24.
16. Rublowsky, *Pop Art*, pp. 95–6, 99, 106, 107.
17. Smith, *Rosenquist*, p. 88.
18. Siegal, *Rosenquist*, p. 32.

Claes Oldenburg

1. For more details see the author's "Eleven from the Reuben Gallery" (New York: Solomon R. Guggenheim Museum, 1965) and Barbara Rose, *Claes Oldenburg* (New York: Museum of Modern Art, 1969).

2. Rose, op.cit., p. 25. Allan Kaprow's "The Legacy of Jackson Pollock," *Art News* (October 1958): 24–6, 55–7.
3. Claes Oldenburg, "Two Poems by Claes Oldenburg," *Penny Poems*, no. 31 (1959).
4. *Store Days*, selected by Claes Oldenburg and Emmett Williams (New York: Something Else Press, 1967), p. 15.
5. Ibid, pp. 51, 137.
6. Ibid, p. 62.
7. Ibid, pp. 39–41.
8. Ibid, p. 45.
9. Ellen Johnson, *Claes Oldenburg* (Baltimore: Penguin Books, 1971), p. 26. Johnson is quoting a letter by the artist.
10. Max Kozloff, "The Poetics of Softness," in Kozloff, *Renderings* (New York: Simon and Schuster, 1968), p. 226.

Andy Warhol

1. Gotham Book Mart, *Andy Warhol: His Early Works 1947-1959,* compiled by Andreas Brown (New York: Gotham Book Mart, 1971).
2. Joseph Masheck, "Warhol As Illustrator: Early Manipulations of the Mundane," *Art in America* 59, no. 3 (1971): 54–9.
3. Rainer Crone, *Warhol* (New York: Praeger, 1970), p. 63.
4. Andy Warhol, "New Talent U.S.A.," *Art in America* 50, no. 1 (1962): 42.
5. G. R. Swenson. "What Is Pop Art?," (Part I) *Art News* 62 (November 1963): 60.
6. Ibid, p. 26.
7. Ibid, p. 26.

4. CONTEXT

1. F. T. Marinetti, "The Founding and Manifesto of Futurism," in 1909, in *Marinetti: Selected Writings,* ed. R. W. Flint (New York: Farrar Straus & Giroux, 1972), p. 40.
2. Reyner Banham, *Theory and Design in the First Machine Age* (London: The Architectural Press, 1960), p. 211.
3. F. T. Marinetti, "Technical Manifesto of Futurist Literature," May 11, 1912, in *Marinetti: Selected Writings*, pp. 84–93.
4. Fernand Léger, "The Machine Esthetic: The Manufactured Object, the Artisan, and the Artist," 1926, in *Léger and Purist Paris* (London: Tate Gallery, 1970), pp. 87–8.
5. Ibid, p. 89.
6. Banham, op. cit., p. 210.
7. Martin L. Friedman, *The Precisionist View in American Art* (Minneapolis: Walker Art Center, 1960), p. 34.
8. Dallas Museum for Contemporary Art, *American Genius in Review,* no. 1 (1960). Introduction by Douglas MacAgy, unpaginated.
9. Abraham A. Davidson, "The Poster Portraits of Charles Demuth," *Auction* III, no. I (September 1969): pp. 28–31.

10. G. R. Swenson, "What Is Pop Art?," (Part I) *Art News* 62 (November 1963): pp. 24–7.

11. John Rublowsky, *Pop Art* (New York: Basic Books, 1965), p. 43.

12. John Coplans, interview in *Roy Lichtenstein* (Pasadena, California: Pasadena Art Museum, 1967), p. 16.

13. Swenson, op. cit.

14. Bruce Glaser, "Oldenburg, Lichtenstein, Warhol: A Discussion," WBAI (radio), 1966. *Artforum* 4, no. 6 (February 1966): 20–4.

15. H .H. Arnason, *Stuart Davis Memorial Exhibition* (Washington, D.C.: National Collection of Fine Arts, Smithsonian Institution, 1965).

16. Stuart Davis (source unavailable).

17. William Homer Innes, *Robert Henri and His Circle.* (Ithaca, New York: Cornell University Press, 1969), p. 81.

18. John Sloan notes, on deposit in the Delaware Art Center. Quoted by Innes, Ibid, p. 82.

19. Barbara Novak, *American Painting of the 19th Century* (New York: Praeger, 1969), pp. 263–64.

20. Leo Marx, "The Vernacular Tradition in American Literature," in Joseph I. Kwiat, Marcy C. Turpie, eds., *Studies in American Culture* (Minneapolis, Minnesota: University of Minnesota Press, 1960), pp. 109-22.

21. Alfred Frankenstein, *The Reality of Appearance* (Berkeley, California: University Art Museum, 1970), p. 60.

22. There are articles on *trompe-l'loeil* painters in *The Magazine of Art* in the 50s, and in 1956, *Art News Annual* 23 surveyed the general field, including nineteenth-century Americans.

23. Frankenstein, op. cit., p. 54.

24. Robert Rosenblum, "Pop Art and Non-Pop Art," originally published in *Art and Literature* (Summer 1964). Reprinted in Suzi Gablik and John Russell, *Pop Art Redefined* (New York: Praeger, 1969), p. 56.

25. Ibid, p. 56.

BIBLIOGRAPHY

This bibliography is critical rather than comprehensive. Further references will be found easily in the bibliographies of summarizing works such as monographs and the catalogs of retrospective exhibitions. This is, I hope, an uncluttered list. The works given here are useful because they record reliable factual data, present interesting interpretations, contain good reproductions, or are historically symptomatic.

The first section covers books, exhibition catalogs, and magazines, in that order, on the general topic of Pop art. The second section is devoted to the individual artists. All sections are arranged chronologically to indicate the status of the movement and the individual artists' reputations on a time scale.

Books

Rublowsky, John. *Pop Art*. Photographer, Ken Heyman. New York: Basic Books Inc., 1965. Lichtenstein, Oldenburg, Rosenquist, Warhol, Wesselman.

Herzka, D. *Pop Art One*. New York: Publishing Institute of American Art, 1965. Excerpts from Rublowsky.

Dienst, Rolf-Gunter. *Pop-Art: Eine Kritische Information*. Limes Verlag, Wies Baden, 1965. Artists' statements. Bibliography.

Amaya, Mario. *Pop as Art*. London: Studio Vista, 1965. Reprinted as *Pop Art . . . And After*. New York: Viking Press, 1966.

Lippard, Lucy R. *Pop Art*. With contributions by Lawrence Alloway, Nancy Marmer, Nicolas Calas. New York: Praeger, 1966.

Russell, John, and Gablik, Suzi. *Pop Art Redefined*. New York: Praeger, 1969. Critical statements and artists' statements reprinted.

Compton, Michael. *Pop Art*. London: Hamlyn Publishing Group, 1970. This and the above book both view British and American Pop art together.

Amaya, Mario. "American Pop Art," in *Art Since Mid-Century*, vol. II, Figurative Art. New York: New York Graphic Society, 1971, pp. 217–41.

Catalogs

Martha Jackson Gallery, New York. *Environments, Situations, Places* (1961). Includes statements by Dine and Oldenburg.

Museum of Modern Art, New York. *The Art of Assemblage* (1961). Text by William C. Seitz. Bibliography. Indiana, Johns, Rauschenberg.

Pasadena Art Museum, Pasadena. *New Paintings of Common Objects* (1962). Text by John Coplans.

Arts Council of the YM/YWHA, Philadelphia. "Art 1963," *A New Vocabulary* (1962). Includes artists' statements.

Sidney Janis Gallery, New York. *New Realists* (1962). Texts by John Ashbery, Pierre Restany, Sidney Janis.

Dwan Gallery, Los Angeles. *My Country 'Tis of Thee* (1962). Text by Gerald Nordland.

Washington Gallery of Modern Art, Washington, D. C. *The Popular Image* (1963). Text by Alan Solomon. Recording of artists' statements.

Nelson Gallery, Atkins Museum, Kansas City, Missouri. *Popular Art* (1963). Text by Ralph Coe. Includes Dine, Lichtenstein, Oldenburg, Rosenquist, Warhol, Wesselmann.

Solomon R. Guggenheim Museum, New York. *6 Painters and the Object* (1963). Text by Lawrence Alloway. Bibliography. Dine, Johns, Lichtenstein, Rauschenberg, Rosenquist, Warhol.

Museum of Modern Art, New York. *Americans 1963* (1963). Selected by Dorothy Miller. Includes Indiana, Oldenburg, Rosenquist.

Los Angeles County Museum, Los Angeles. *Six More* (1963). Text by Lawrence Alloway (companion to *6 Painters and the Object*). Bengston, Goode, Hefferton, Ramos, Ruscha, Thiebaud.

Oakland Art Museum, Oakland, California. *Pop Art USA* (1963). Text by John Coplans. Broad-based survey.

Moderna Museet, Stockholm. *Amerikanste Pop-Kunst* (1964). Texts by Alan R. Solomon and Billy Kluver. Dine, Lichtenstein, Oldenburg, Rosenquist, Warhol, Wesselmann.

Gemeentemuseum, The Hague. *Nieuwe Realisten* (1969). Various texts. Loose survey of figurative art, includes Pop art.

Akademie der Kunst, Berlin. *Neue Realisten & Pop Art* (1964). Text by Werner Hofmann. Version of the *Nieuwe Realisten* exhibition.

Museum des 20 Jahrhunderts, Vienna. *Pop, etc.* (1964). Text by Werner Hoffmann and Antonin Graf. Statements by artists.

Worcester Art Museum, Worcester, Massachusetts. *The New American Realism* (1965). Texts by Daniel Catton Rich and Martin Carey. Artists' statements. Broad-based survey.

Solomon R. Guggenheim Museum, New York. *Eleven from the Reuben Gallery* (1965). Text by Lawrence Alloway. Chronology of exhibitions and Happenings, 1959–61.

Milwaukee Art Center, Milwaukee. *Pop Art and the American Tradition* (1965). Text by Tracy Atkinson. Links Pop art with traditional Americana.

Art Gallery, University of California, Irvine. *New York, The Second Breakthrough, 1959–1964* (1965). Text by Alan Solomon. Dine, Johns, Lichtenstein, Oldenburg, Rauschenberg, Rosenquist, Warhol.

Kunstverein, Frankfurt. *Kompass, Paintings after 1945 in New York* (1967). Text by J. Leering. Lichtenstein, Rosenquist, Johns, Oldenburg, Rauschenberg, Warhol.

São Paulo, 9, Brazil. *USA Environment USA:1957-1967* (1967). Text by William C. Seitz. Includes D'Arcangelo, Indiana, Johns, Lichtenstein, Oldenburg, Rauschenberg, Rosenquist, Ruscha, Warhol, Wesselmann.

Pasadena Art Museum, Pasadena. *Serial Imagery* (1968). Text by John Coplans. Includes Warhol.

Metropolitan Museum of Art, New York. *New York Painting and Sculpture 1940–70* (1969). Text by Henry Geldzahler. Bibliography. Johns, Lichtenstein, Oldenburg, Rauschenberg, Rosenquist, Warhol.

Wallraf-Richartz-Museum, Cologne. *Kunst der Sechziges Jahre* (1969). Sammburg Ludwig. Texts by Peter Ludwig, Horst Keller, Evelyn Weiss. Dine, Indiana, Johns, Lichtenstein, Oldenburg, Rauschenberg, Rosenquist, Warhol.

Hessischen Landesmuseum, Darmstadt, West Germany. *Bildnerische Ausdrucksformend 1960-1970* Sammlung Karl Ströher (1970). Texts by Gerhard Bott and Karl Ströher. A collection strong on Lichtenstein, Oldenburg, and Warhol.

Philadelphia Museum of Art, Philadelphia. *Multiples. The First Decade* (1971). Text by John L. Tancock. Artschwager, Dine, Lichtenstein, Oldenburg, Rauschenberg, Rosenquist, Ruscha, Warhol, Wesselmann.

Neue Galerie der Stadt, Aachen. *Kunst um 1970. Sammlung Ludwig in Aachen* (1972). Indiana, Lichtenstein, Ramos, Rauschenberg, Wesselmann.

Magazine Articles

Kozloff, Max. "Pop Culture, Metaphysical Disgust or the New Vulgarians" (*Art International*, Zurich, 6, 2, 1962) pp. 34–6. The first article in an art magazine on the subject.

Seckler, Dorothy Gees. "Folklore of the Banal" (*Art in America*, Winter 1962) pp. 52–61. Statements.

Swenson, G. R. "The New American Sign Painters" (*Art News*, September 1962) pp. 45–7, 61–2.

Coplans, John. "The New Painting of Common Objects," with a "Chronology: The Common Object and Art" (*Artforum*, San Francisco, 1, 6, 1962) pp. 26–9.

Sorrentino, Gilbert. "Kitsch Into 'Art': The New Realism" (*Kulchur*, New York, 2, 8, 1962) pp. 10–23. Underground put-down of Pop art.

Johnson, Ellen H. "The Living Object" (*Art International*, Zurich, 7, 1, January 1963) pp. 42–5.

Rudikoff, Sonya. "New Realists in New York" (*Art International*, Zurich, 7, 1, January 1963) pp. 39–41. The author proposes *American Dream Painting* as an alternative term to *Pop art*.

Swenson, G. R. "What Is Pop Art?" (Part I) (*Art News* 62 November 1963) pp. 24–7, 61–5; (Part II) (*Art News*, February 1964) pp. 40–3, 62–6.

Interviews with Dine, Steven Durkee, Indiana, Johns, Lichtenstein, Rosenquist, Warhol, Wesselmann.

Arts Magazine, "A Symposium on Pop Art," April 1963, pp. 36–45. Record of symposium at Museum of Modern Art, New York, December 13, 1962, with Dore Ashton, Henry Geldzahler, Hilton Kramer, Stanley Kunitz, Leo Steinberg, and Peter Selz, moderator.

Rose, Barbara. "Dada Then and Now" (*Art International*, Zurich, 7, 1, 1963) pp. 22–8; paired with Pierre Restany," le Nouveau Realisme à la Conquete de New York," pp. 29–36.

Rose, Barbara. "Pop Art at the Guggenheim" (*Art International*, Zurich, 6, 5, 1963) pp. 20–2.

Karl, Ivan C. "Anti-Sensibility Painting" (*Artforum*, San Francisco, September 1963) pp. 26–7.

Solomon, Alan. "The New Art" (*Art International*, Zurich, 7, 7 September 1963) pp. 37–41. (Reprint of the text of *The Popular Image*.)

Solomon, Alan. "The New American Art" (*Art International*, Zurich, 8, 2, 1964) p. 50–5. (English text of *Amerikanste Pop-Kunst*.)

Das Kunstwerk. "Pop-Art Diskussion," 17, 10, April 1964. Special issue with various writers and artists.

Kelly, Edward T. "Neo-Dada: A Critique of Pop Art" (*Art Journal*, New York, Spring 1964) pp. 192–201. Academic put-down of Pop art.

Nordland, Gerald. "Marcel Duchamp and Common Object Art" (*Art International*, Zurich, 8, 1, 1964) pp. 30–2.

Calas, Nicolas. "Why Not Pop Art?" (*Art and Literature*, Paris, 4, Spring 1965) pp. 178–84.

Rosenblum, Robert. "Pop Art and Non-Pop Art" (*Art and Literature*, Paris, 5, Summer 1965) pp. 80–93.

Johnson, Ellen H. "Jim Dine and Jasper Johns" (*Art and Literature*, Paris, 6, Autumn 1965) pp. 128–40.

Johnson, Ellen. "The Image Duplicators—Lichenstein, Rauschenberg, and Warhol" (*Canadian Art*, 23, 1, January 1966) pp. 12–18.

ARTISTS

Artschwager

"Object: Still-life; Interview." (September 1965) *Craft Horizons* 25, pp. 28–30ff.

Artschwager, Richard. "Hydraulic Door Check." (November 1967) *Arts Magazine* 42, pp. 41–3.

Baker, E. C. "Artschwager's Mental Furniture." (January 1968) *Art News* 66, pp. 48–9ff.

Museum of Contemporary Art, Chicago. *Richard Artschwager* (1973). Text by Artschwager and Catherine Kord.

Bengston

Los Angeles County Museum. *Billy Al Bengston* (1968). Text by James Monte. Bibliography.

Dine

Sidney Janis Gallery, New York. *Jim Dine* (1963). Text by Oyvind Fahlstrom.

Apollinaire, Guillaume. *The Poet Assassinated*. Translated by Ron Padgett. Illustrated by Jim Dine. New York: Holt, Rinehart and Winston, 1968.

Museum of Modern Art, New York. *Jim Dine: Designs for A Midsummer Night's Dream* (1968). Introduction by Virginia Allan.

Whitney Museum of American Art, New York. *Jim Dine* (1970). Text by Jack Gordon. Bibliography. Chronology.

Andrew Dickson White Museum of Art, Cornell University. *Nancy and I in Ithaca.* (1967). Notes by William C. Lipke.

Kozloff, Max. "The Honest Elusiveness of Jim Dine." (*Artforum* 3, December 1964) pp. 36–40.

Solomon, Alan R. "Jim Dine and the Psychology of the New Art." (*Art International* 8, October 20, 1964) pp. 52–6.

Goode

Fort Worth Art Center Museum, Fort Worth. *Joe Goode: Work Until Now* (1972). Text by Henry Hopkins. Bibliography.

Indiana

Walker Art Center, Minneapolis. *Stankiewicz and Indiana* (1963). Text by the artists.

Swenson, G. R. *Robert Indiana.* (*Art News*, June 1966).

Indiana, Robert and Creeley, Robert. *Numbers.* Edition Domberger Stüttgart, Schmela Düsseldorf, 1968. Introduction of Dieter Honisch.

Institute of Contemporary Art, University of Pennsylvania, Philadelphia. *Robert Indiana* (1968). John W. McCoubrey. Statement by the artist and "autochronology."

Johns

The Jewish Museum, New York. *Jasper Johns* (1964). Alan R. Solomon. Includes John Cage: "Jasper Johns: Stories and Ideas." Bibliography.

Krauss, Rosalind. "Jasper Johns." *Lugano Review* 1, 2, 1965) pp. 84–98.

Kozloff, Max. *Jasper Johns.* New York: Abrams, n.d. [1967]. Bibliography. Good illustrations up to 1964.

Field, Richard S. *Jasper Johns Prints 1960–70.* New York: Praeger, 1970.

Museum of Modern Art, New York. *Jasper Johns Lithographs* (1970). Riva Castleman.

Kozloff, Max. *Jasper Johns.* New York: Abrams, n.d. [1972]. A revised text from Kobloff's earlier book.

Lichtenstein

Boatto, Alberto, and Falzoni, Giordano, eds., special issue on Lichtenstein. (*Fantazasia* 1, no. 2, July–August 1966). Magazine published in Rome reprints American and European articles.

Pasadena Art Museum, Pasadena. *Roy Lichtenstein* (1967). John Coplans. Interview. Bibliography.

Tate Gallery, London. *Roy Lichtenstein* (1968). Richard Morphet. Chronology of Lichtenstein's imagery. Bibliography.

Solomon R. Guggenheim Museum, New York. *Roy Lichtenstein* (1969). Diane Waldman. Bibliography.

Waldman, Diane. *Roy Lichtenstein.* New York: Abrams, n.d. [1971]. Bibliography. Illustrations up to 1969.

Coplans, John, ed. *Roy Lichtenstein.* New York: Praeger, 1972. "Chronology of Imagery and Art." Reprints interviews by Coplans (3), Glaser, Siegal, Solomon, Swenson, Tuten, Waldman, and critical essays by various writers.

Oldenburg

Store Days. Selected by Claes Oldenburg and Emmett Williams. New York: Something Else Press, 1967.

Baro, Gene. *Claes Oldenburg: Drawings and Prints.* New York: Chelsea House, 1969. *Catalogue raisonné* of drawings, 1958–67, and prints 1960–67.

Oldenburg, Claes. *Proposals for Monuments and Buildings, 1965–69.* Chicago: Big Table Publishing Co., 1969. Interview with Paul Carroll.

Rose, Barbara. *Claes Oldenburg* (1970). Museum of Modern Art, New York. Bibliography. The best book on any of the Pop artists.

Johnson, Ellen. *Claes Oldenburg.* Baltimore: Penguin Books, 1971. Excellent text.

Oldenburg, Claes. *Notes in Hand.* New York: E. P. Dutton, 1971. (Typographical version of Oldenburg's notebooks.)

Ramos

Ramos, Mel. *Aachen: Zentrüm für aktuelle Kunst.* (1969). Text by Klaus Honnef. Bibliography.

Skelton, R. "Art of Mel Ramos." (*Art International* 13, March 1969) pp. 43–5. Deals with Ramos' girlie paintings.

Rauschenberg

Cage, John. *Silence.* Middletown, Connecticut: Wesleyan University Press, 1961. "On Robert Rauschenberg, Artist and His Work," pp. 98–108.

The Jewish Museum, New York. *Robert Rauschenberg* (1963). Alan R. Solomon. Bibliography.

Forge, Andrew. *Rauschenberg.* New York: Abrams, n.d. [1969]. Bibliography. Text rendered illegible by the artist's layout. Richly illustrated.

Dayton's Gallery 12 and Castelli Graphics. *Rauschenberg's Currents.* (1970).

Institute of Contemporary Art, University of Pennsylvania. *Rauschenberg: Graphic Art* (1970). Lawrence Alloway. *Catalogue raisonné* of Rauschenberg's prints.

Rivers

The Jewish Museum. *Larry Rivers* (1965). Text by Sam Hunter. Bibliography.

Hunter, Sam. *Larry Rivers.* New York: Abrams, n.d. [1970]. Bibliography.

Silver, Jonathan. "Larry Rivers by Sam Hunter." (*The Print Collector's Newsletter* 1, 3, July–August 1970) pp. 67–9.

Rosenquist

Swenson, G. R. "The F-111: An Interview with James Rosenquist." (*Partisan Review* 32, Fall 1965) pp. 589–601.

National Gallery of Canada, Ottowa. *James Rosenquist* (1968). Brydon Smith. "Experiences" by the artist. Brief bibliography. Chronology.

Whitney Museum of American Art, New York. *James Rosenquist* (1972). Marcia Tucker. Chronology, bibliography, and a listing of Rosenquist's prints.

Ruscha

Coplans, John. "Concerning 'Various Small Fires': Edward Ruscha Discusses His Perplexing Publications." (*Artforum* 3, 5, February 1965) pp. 24–5.

Newport Harbor Museum, Balboa, California. *Joe Goode and Edward Ruscha* (1968). Text by Henry T. Hopkins.

Alexander Iolas Gallery, New York. *Ruscha* (n.d.). Text by Henry T. Hopkins.

Bourdon, David. "Ruscha As Publisher (or All Booked Up)." (*Art News*, April 1972) pp. 32–6.

Ruscha, Edward. The following is a partial list of Ruscha's personally published books:
> *Twenty-six Gasoline Stations.* 1962.
> *Various Small Fires and Milk.* 1964.
> *Some Los Angeles Apartments.* 1965.
> *Every Building on the Sunset Strip.* 1966.
> *Thirty-four Parking Lots.* 1967.
> *Crackers.* 1969.
> *A Few Palm Trees.* 1971.
> *Colored People.* 1972.

Warhol

Stable Gallery, New York. *Andy Warhol* (1962). Suzy Stanton: "On Warhol's Campbell's Soup Can."

Institute for the Arts, Houston. *Raid the Icebox No. 1,* with Andy Warhol, (1969). "An exhibition selected from the storage vaults of the Museum of Art, Rhode Island School of Design." Texts by Daniel Robbins and David Bourdon.

Bourdon, David. "Plastic Man Meets Plastic Man." (*New York*, February 10, 1969) pp. 44–6. Warhol and Les Levine.

Crone, Rainer. *Andy Warhol.* New York: Praeger, 1970. Bibliography and a (preliminary) *catalogue raisonné.* Interesting details of the early work.

Coplans, John. *Andy Warhol.* New York: New York Graphic Society, 1971. With contributions by Jonas Mekas and Calvin Tomkins. Bibliography. The best all-round coverage.

Gotham Book Mart, New York. *Andy Warhol: His Early Works 1947–1959* (1971). Compiled by Andreas Brown. Deals with Warhol's commercial graphics.

Wilcock, John, ed. *The Autobiography and Sexlife of Andy Warhol*. New York: Other Scenes, 1971. Interviews include: Eleanor Ward, Ivan Karp, Leo Castelli, Henry Geldzahler.

Art in America 59, 3, May–June 1971. Special issue. Mary Josephson, "Warhol: The Medium As Cultural Artifact," pp. 41–6; Carolyn Betsch, "A Catalogue Raisonné of Warhol's Gestures," p. 47; David Bourdon, "Warhol As Film Maker," pp. 48–53; Joseph Masheck, "Warhol As Illustrator: Early Manipulations of the Mundane," pp. 54–9.

Wesselmann

Abramson, J. A. "Tom Wesselmann and the Gates of Horn." (*Arts Magazine* 40, May 1966) pp. 43–8.

Clair, J. "L'influence de Matisse aux Etats-Unis" (with English summary). (*XXᵉ Siecle* ns. 35, December 1970) p. 160. *Illustrated:* Gran nu american, p. 159.

Newport Harbor Museum, Balboa, California. *Tom Wesselmann: Early Still Lifes, 1962–1964* (1970). Text by Thomas Garver, Bibliography

"Wesselmann's Fancy Footwork." Photographed by Bob Adelman. (*Art Voices*, Summer 1966). Shows the artist working from a model.

Essays, Collected

Calas, Nicolas. *Art in the Age of Risk*. New York: E. P. Dutton, 1968. Section II, "Focus on Pop," pp. 41–76; "Robert Rauschenberg," pp. 169–93; "Jim Dine, Tools and Myth," pp. 199–200; "Allen D'Arcangelo," pp. 201–7.

Calas, Nicolas and Calas, Elena. *Icons and Images of the 60s*. New York: E. P. Dutton, 1971. "Rauschenberg at the Controls," pp. 65–71; "Jasper Johns: And/Or," pp. 72–82; section on Pop art, pp. 85–130; "Robert Indiana and His Injunctions," pp. 139–44.

Kozloff, Max. *Renderings*. New York: Simon and Schuster, 1968. "Jasper Johns," pp. 206–11; "Robert Rauschenberg," pp. 212–15; "The Poetics of Softness," pp. 223–35.

Lippard, Lucy R. *Changing*. New York: E. P. Dutton, 1971. "James Rosenquist: Aspects of a Multiple Art," pp. 87–97.

INDEX

A

Abstract expressionism, 19, 21, 32, 42, 55, 115
Anti-Sensibility painting, 24
Arnason, H. H., 118–19
Art Deco, 78, 118
Artschwager, Richard, 32
Ash-Can School, 119

B

Bengston, Billy Al, 32–35
Blaue Reiter, Der, 116
Botticelli, Sandro, 58
Braque, Georges, 117
Brancusi, Constantin, 51
Brecht, George, 20
Brücke, Die, 116

C

Cage, John, 35, 52
Calas, Elena, 89

Calas, Nicolas, 72, 80, 89
Cathcart, Linda, 91
Cézanne, Paul, 118
Cocteau, Jean, 104
Common Object Art, 24
Conner, Bruce, 89
Coplans, John, 84, 109
Creeley, Robert, 35
Cunningham, Merce, 52

D

Dadaism, 116
Daumier, Honoré, 3, 20
Davis, Stuart, 118–19
Davis, William M., 125
De Hooch, Pieter, 58
De Kooning, Willem, 19, 32, 98, 120
Degas, Edgar, 58, 115
Demuth, Charles, 117
Dine, Jim, 19, 20, 35, 42, 97, 98
Drexler, Rosalyn, 98
Dubuffet, Jean, 99
Duchamp, Marcel, 7, 66, 114, 117

E

Environment, 20, 42
Estes, Richard, 89
Expressionism, 20, 32, 95

F

Fahlstrom, Oyvind, 5, 65–66
Familiarity of subject, 19
Fluxus, 20
Frankenstein, Alfred, 120, 125
Futurism, 53, 115–16

G

Gabo, Naum, 53
Gleizes, Albert, 21
Golding, John, 118
Goya, Francisco José, 3, 58
Greenberg, Clement, 9
Gris, Juan, 80, 117
Grooms, Red, 20, 98

H

Haberle, John, 120
Happening, 2, 18, 19, 20, 23, 98, 103
Harnett, William, 120
Hartley, Marsden, 117
Hefferton, Phillip C., 120, 121
Hofmann, Hans, 72
Hogarth, William, 3
Hopper, Edward, 20
Hunter, Sam, 21

I

Immaculates, 117
Indiana, Robert, 19, 35, 88, 117, 119, 120, 125
Innes, William Homer, 119

J

Johns, Jasper, 18, 19, 20, 21, 32, 35, 47, 52, 53, 55, 66–75, 97, 98, 104, 117, 120
Johnson, Ellen, 103
Junk Culture, 58

K

Kane, Bob, 16
Kaprow, Allan, 2, 18, 20, 98, 99
Katz, Alex, 21
Kelly, Ellsworth, 19, 125
Kienholz, Edward, 9
Kierkegaard, Søren, 42–47
Kline, Franz, 32
Koch, Kenneth, 21
Kozloff, Max, 71, 104

L

Le Corbusier, 116, 117
Léger, Fernand, 80, 116–17, 118, 119
Leonardo da Vinci, 63
Lichtenstein, Roy, 7, 9, 16, 19, 20, 24, 32, 47–51, 75–86, 88, 93, 97, 98, 101, 113, 118, 119, 120–25
Lippard, Lucy, 91, 93
Lissitsky, El, 53
Lozowick, Louis, 117

M

McLuhan, Marshall, 4
Magritte, René, 35
Marinetti, F. T., 116
Marisol, 23
Marx, Leo, 119–20
Matisse, Henri, 47
Miro, Joan, 80
Monet, Claude, 78, 84
Munch, Edvard, 116
Murphy, Gerald, 117

N

Newman, Barnett, 32
New Realism, 24
Noland, Kenneth, 72
Novak, Barbara, 32, 119

O

Oldenburg, Claes, 19, 20, 23, 42, 51,
 98–104
Ozenfant, Amédée, 116, 117

P

Peale, Charles Willson, 120
Picabia, Francis, 117
Picasso, Pablo, 9, 51, 80, 117, 118
Pollock, Jackson, 19, 32, 99, 120
Pop art
 American components, 18–19, 115,
 119, 120
 anthropology and, 5–7, 18
 characteristics, 19
 and comic strips, 7–18, 47, 118
 commonality, 7–9
 connection with technology, 19
 diversity, 20–23
 environment and, 20, 42
 fact and, 42
 familiarity of subject, 19
 and fine art, 3
 and Happening, 2
 human figure in, 24
 and mass media, 4–5, 7, 9, 18, 47,
 65
 objects, 32–35, 42, 47
 origins, 1–2
 and popular culture, 1–2, 7, 9, 16,
 18, 47, 98, 104, 109
 process abbreviation, 16–18
 range of media, 19

references to other art works,
 47–51
 and sign-system, 7–9
 signs, 35–42, 47
 simultaneous discovery, 9–16
 syntactic complexity, 19
 technical permormance, 18–19
 and twentieth-century art, 115–25
Process abbreviation, 16–18
Purism, 115–16, 117, 118, 119

R

Ramos, Mel, 16, 21
Range of media, 19
Ranney, William, 120
Rauschenberg, Robert, 5, 18, 19, 20,
 21, 24, 47, 52–53, 55–66, 98,
 99, 104, 114, 120
Renoir, Pierre Auguste, 58
Restany, Pierre, 24
Reuben, Anita, 98
Rivers, Larry, 20, 21–23
Robbe-Grillet, Alain, 78
Rose, Barbara, 98–99
Rosenberg, Harold, 9
Rosenblum, Robert, 125
Rosenquist, James, 19, 86–98, 101
Rothko, Mark, 20, 32
Rubens, Peter Paul, 47
Ruscha, Ed, 35–42, 47

S

Samaras, Lucas, 20, 23, 98
Segal, George, 20, 98
Shahn, Ben, 104
Sheeler, Charles, 117, 119
Sloane, John, 119
Spencer, Niles, 117
Steinberg, Leo, 69
Stella, Frank, 19, 32, 72
Syntactic complexity, 19

T

Thiebaud, Wayne, 20–21
Toulouse-Lautrec, Henri de, 3, 115, 116
Trompe-l'oeil, 120–25
Tucker, Marcia, 88, 93

V

Van Gogh, Vincent, 9, 58, 78, 116
Velazquez, Diego, 47, 63

Vermeer, Jan, 58
Vinklers, Bitite, 65

W

Waldman, Diane, 80
Warhol, Andy, 7, 9, 16, 18, 19, 20, 21, 24, 32, 98, 101, 103, 104–14, 120
Wesselmann, Tom, 19, 24, 47
Whitman, Robert, 20, 98
Whitman, Walt, 101, 120, 125
Watts, Robert, 1, 20

105. (Overleaf) Jasper Johns. *Target with Plaster Casts.* 1955. Encaustic and collage on canvas with plaster casts. 51 x 44 x 3½. Collection of Mr. and Mrs. Leo Castelli, New York.

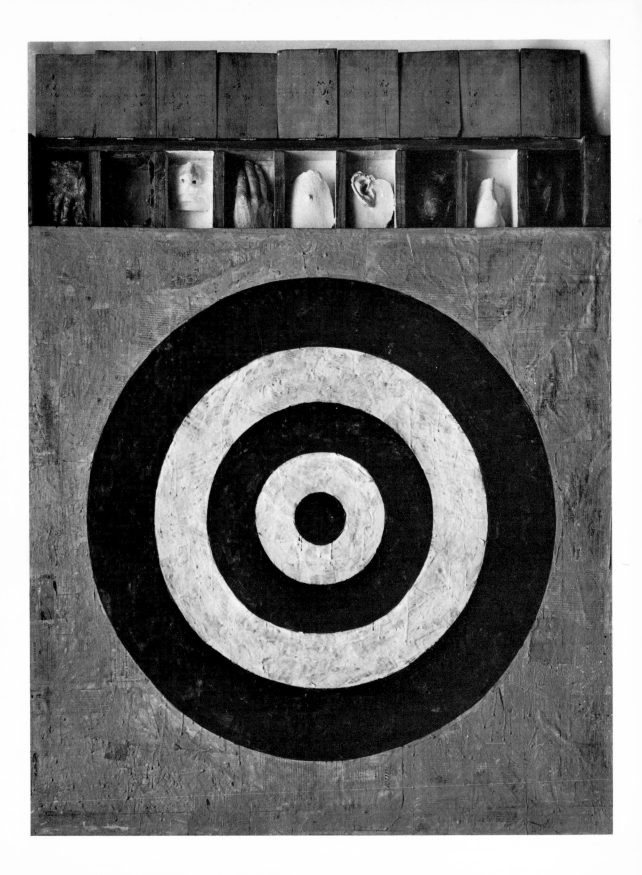